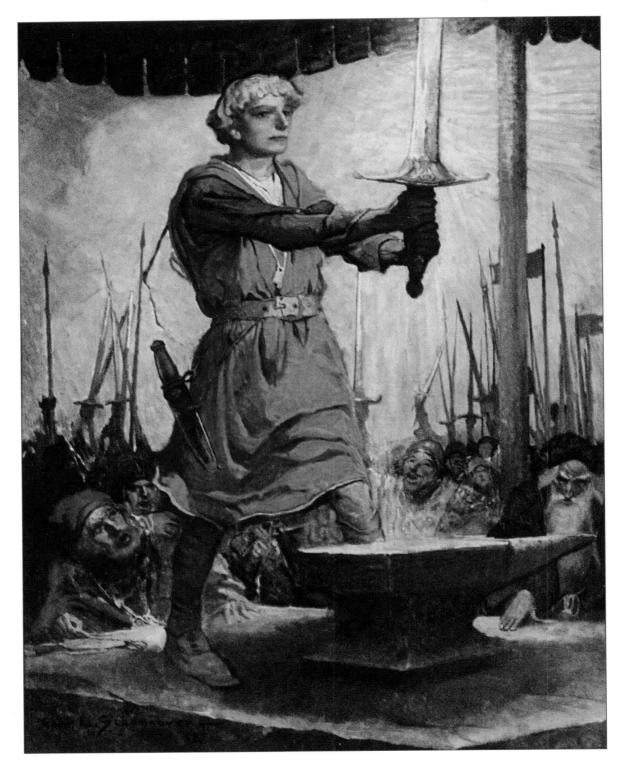

King Arthur and his Knights, 1923
FRANK SCHOONOVER

Frontispiece

Visions of Camelot

GREAT ILLUSTRATIONS OF KING ARTHUR AND HIS COURT

SELECTED AND EDITED BY JEFF A. MENGES

DOVER PUBLICATIONS, INC.

Mineola, New York

Bibliographical Note

This Dover edition, first published in 2009, is an original compilation of illustrations from the following sources: Aubrey Beardsley (illustrator), *Le Morte D'Arthur* (J. M. Dent, London, 1893–1894); William Ernest Chapman (illustrator); *The Story of Sir Galahad* (E. P. Dutton & Co., New York, 1908); Walter Crane (illustrator), *King Arthur's Knights* (Frederick A. Stokes Co., New York, 1911); William Russell Flint (illustrator), *Le Morte Darthur* (Philip Lee Warner, London, 1911); H. J. Ford (illustrator), *The Book of Romance* (Longmans, Green and Co., London, 1902); Thomas Mackenzie (illustrator), *Arthur and his Knights* (Nisbet & Co., Ltd., London, 1920); Willy Pogány, *Parsifal* (Harrap & Co., London, 1912); Howard Pyle, *The Story of King Arthur and his Knights* (Charles Scribner's Sons, New York, 1903), *The Story of the Champions of the Round Table* (Scribner's, New York, 1905), *The Story of Sir Launcelot and his Companions* (Scribner's, 1907), *The Story of the Grail and the Passing of Arthur* (Scribner's, 1910); Arthur Rackham (illustrator), *The Romance of King Arthur* (Macmillan, New York, 1917); Louis Rhead and Frank Schoonover (illustrators), *King Arthur and his Knights* (Harper and Brothers, Publishers, New York and London, 1923); and N. C. Wyeth (illustrator), *The Boy's King Arthur* (Scribner's, New York, 1917).
NOTE: Caption punctuation varies according to the original source.

Library of Congress Cataloging-in-Publication Data

Visions of Camelot : great illustrations of King Arthur and his court / selected and edited by Jeff A. Menges.
 p. cm.
 ISBN-13: 978-0-486-46816-7
 ISBN-10: 0-486-46816-X
 1. Arthurian romances—Illustrations. I. Menges, Jeff A.
N8215.V57 2009
741.6'4—dc22

2008041785

Manufactured in the United States of America
Dover Publications, Inc., 31 East 2nd Street, Mineola, N.Y. 11501

FOR BILL

INTRODUCTION

The tales of King Arthur and his court at Camelot have proven to be a source of lasting fascination for both readers and artists. The stories—legendary tales of Arthur and Merlin, Lancelot and Guinevere, and the knights, as well as the lore of the sword Excalibur and the pursuit of the Holy Grail (Sangreal)—are shining examples of courage, nobility, and chivalry that speak of a time when these ideals were of prime importance. For the inhabitants of the British Isles, there is also a sense of national identity and pride associated with the tales, which adds to their power.

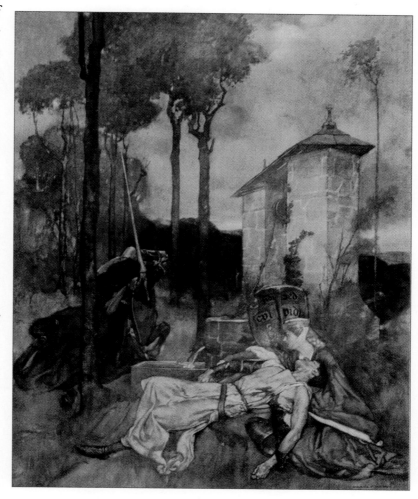

"When she saw he would not abide, she prayed unto God to send him as much need of help as she had, and that he might feel it or he died."—Book III, Chapter XII
Le Morte Darthur, Vol. I, William Russell Flint, 1911

As attractive as the setting of Camelot is in literary terms to the reader, it is perhaps even more evocative visually. The deep forests and rocky shores of the English countryside, as well as the architecture of the castles, colorful costume, and intricate armor crafted for kings—all offer a feast for the eyes. For readers who have delighted in the story's illustrations, as well as for the artists who have portrayed the events and deeds, the tales of King Arthur and his court have, for centuries, provided a wealth of fantastic visual material. The stories are full of drama, containing emotions ranging from the deepest love to the most devastating, vengeful malice.

When Sir Thomas Malory collected the tales of Arthur's court into *Le Morte D'Arthur* between the years 1469 and 1470, he drew from several earlier manuscript

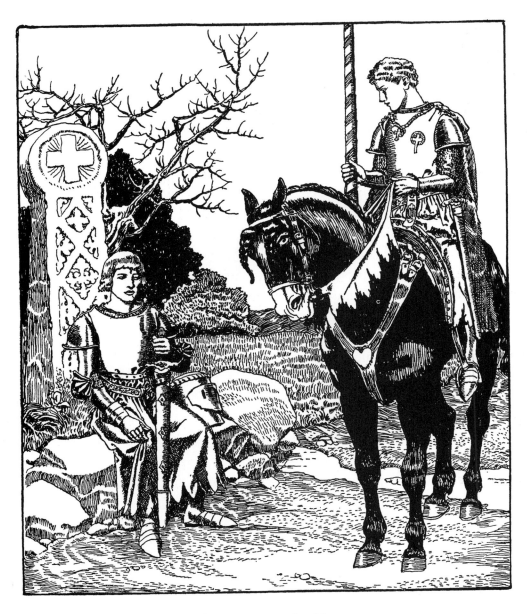

SIR GALAHAD MEETS SIR MELYAS
The Story of the Grail and the Passing of Arthur, Howard Pyle, 1910

sources, including the Welsh epic *Mabinogian* and Chrétien de Troyes' twelfth-century French tales of Tristan and Lancelot. A few years later, in 1477, William Caxton—the first printer working on English soil—was selecting material for his early volumes. Caxton was pressed by many to look to the tales of Arthur, making them much more accessible to the country in which these legendary stories took place. It was here that Malory's manuscript became the basis for Caxton's printed edition, which, in turn, became the source for every reprint or retelling to follow. Caxton's foresight was correct: The story would become a vibrant part of British identity, impressed upon all of European culture and well known the world over.

During the reign of Queen Victoria (1837 to 1901), interest in the stories of King Arthur was remarkably strong due to several factors. As warfare became less personal due to the use of rifle and cannon, the nobility of combat was vanishing from the battlefield. The captivating tales of Camelot were a means of holding on to such chivalrous ideals. Painters such as Sir Edward Burne-Jones and John William Waterhouse, and writers, including Alfred Lord Tennyson and T. H. White, have found inspiration in Arthurian themes.

Printing processes during the Victorian era improved to the extent that not only were multiple editions becoming available at set times, but also variations in the narratives—that is, editions printed for young readers, offering simpler language and more concise storylines. The single element that had become the key component to each edition's individuality was the imagery that accompanied the text. The late nineteenth and early twentieth century produced a group of wonderfully illustrated volumes by a range of artists across Europe and the United Kingdom, as well as America. In 1893, Aubrey Beardsley's powerful graphic style brought the tales of Arthur to a new level of interest. The subject attracted the best talent that the illustration field had to offer, William Russell Flint and Walter Crane in England, and Howard Pyle and N. C. Wyeth in the United States, to name only the top of the list.

The *Morte D'Arthur* occupies a unique place within literature. It is the last major book written in English before the introduction of printing, and one of the first works available to a new age of readers as a printed text. While this timely placement makes it of historical interest, it is the messages and examples contained within, and its value as entertainment, that keep readers coming back to it today.

Jeff A. Menges
November 2008

ARTISTS & VOLUMES

THE PLATES

Merlin

AUBREY BEARDSLEY

AUBREY BEARDSLEY, 1872–1898
Le Morte D'Arthur, 1893–94

During his tragically short life—which could be described as a flash of brilliance—Aubrey Beardsley produced many influential works and enduring images. A prodigy whose work was first published when he was thirteen, Beardsley saw his artwork appear in magazines and journals in his youth. He was approached by publisher J. M. Dent to tackle a massive undertaking—the production of more than 300 images for Sir Thomas Malory's *Morte D'Arthur*. The commission would occupy Beardsley for over a year, a commitment made even more poignant because Beardsley did not live to see his twenty-sixth birthday. He succumbed to tuberculosis, which had plagued him all of his brief adult life. The iconic and contrast-heavy style that Beardsley developed at the end of the Arthur project made his work easily recognizable a century later. He is remembered as one of the leading figures in Art Nouveau illustration.

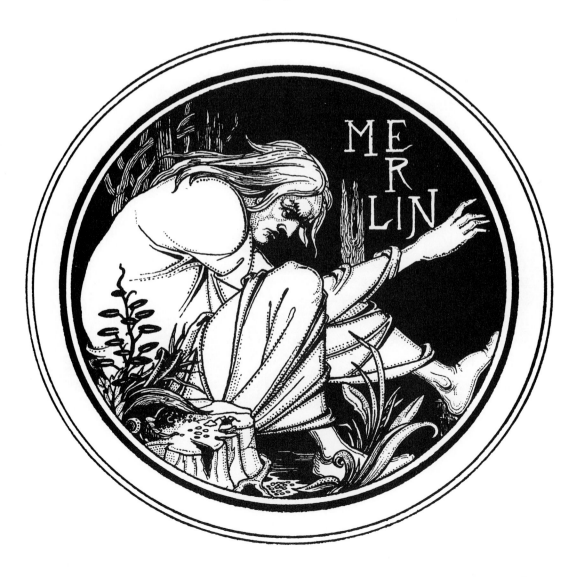

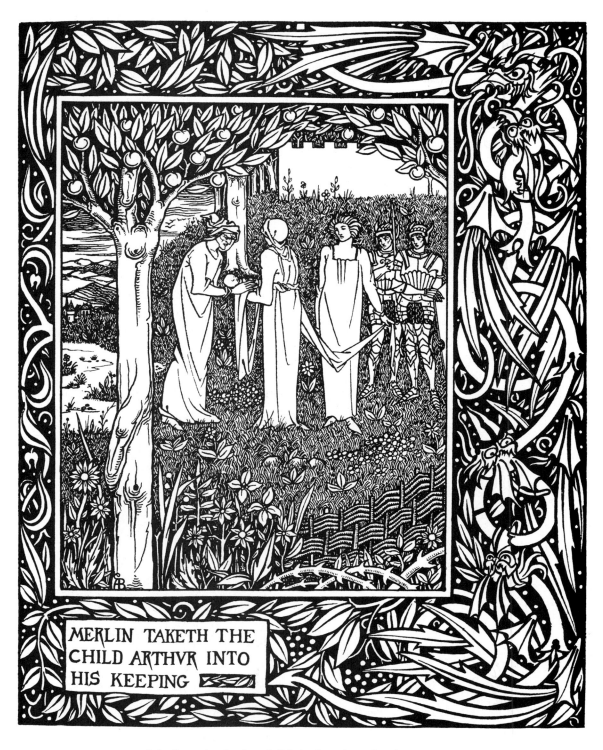

Merlin taketh the child Arthur into his keeping

AUBREY BEARDSLEY

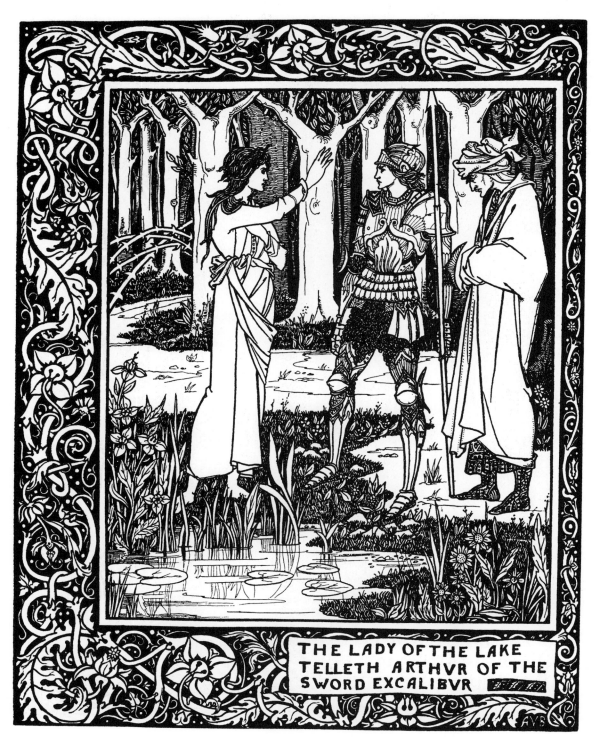

The Lady of the Lake telleth Arthur of the Sword Excalibur

AUBREY BEARDSLEY

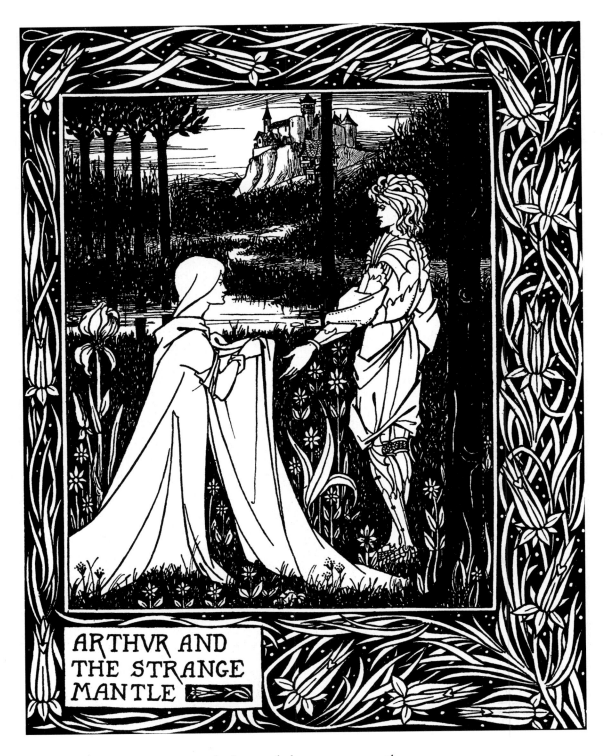

Arthur and the strange mantle

AUBREY BEARDSLEY

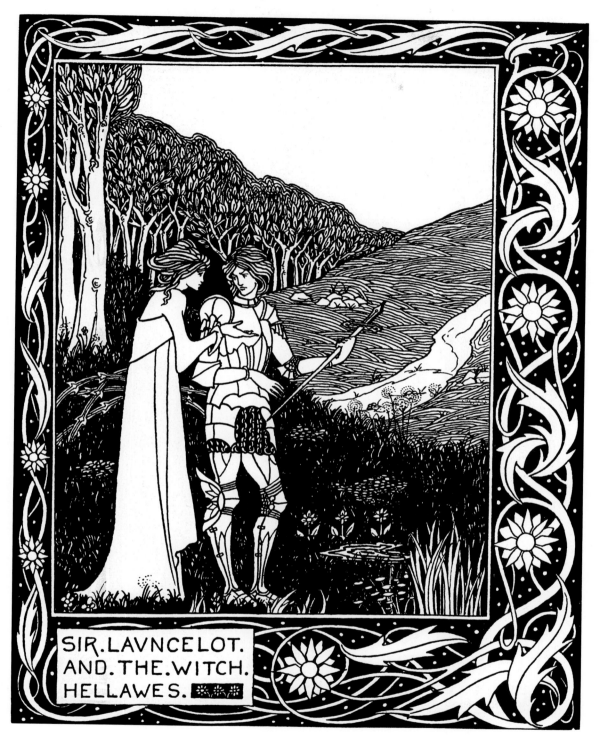

Sir Launcelot and the Witch Hellawes

AUBREY BEARDSLEY

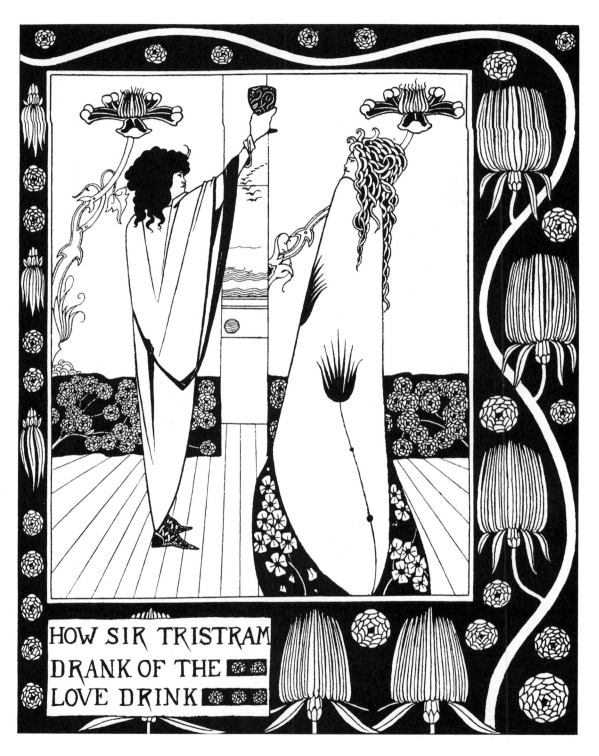

How Sir Tristram drank of the love drink

Aubrey Beardsley

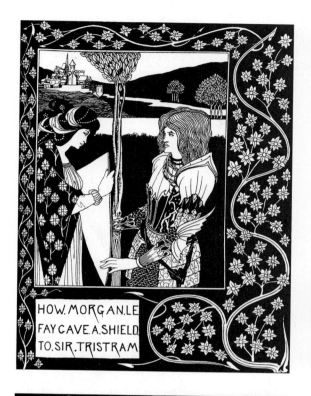

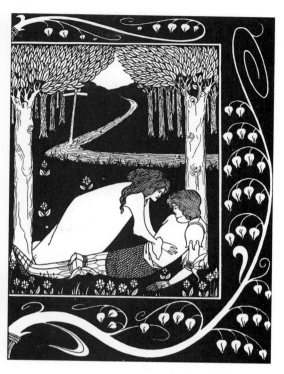

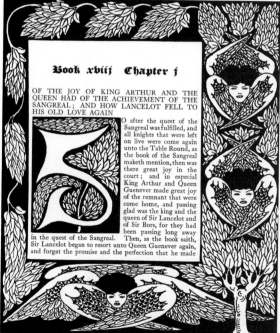

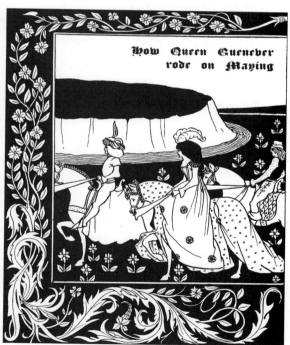

TOP LEFT: How Morgan le Fay gave a shield to Sir Tristram
TOP RIGHT: How Sir Lancelot was known by Dame Elaine
BOTTOM LEFT: *Book xviii Chapter 1* Frame
BOTTOM RIGHT: How Queen Guenever rode on Maying

AUBREY BEARDSLEY

Sir Bors sees the child Galahad

WILLIAM ERNEST CHAPMAN

WILLIAM ERNEST CHAPMAN, 1858–1947
The Story of Sir Galahad, 1908

An American illustrator and painter, Chapman studied in both New York and Europe with the French Romantic painter Bourgereau and American artist and instructor John Vanderpoel, among others. While his studio work appears to have had traditional themes, his two better-known illustrated books both were devoted to Arthurian themes. His work here in *The Story of Sir Galahad*—adapted from Malory—is notable because of the large expanses of flat color and the stained-glass qualities of the images. Chapman was active in the illustration field from 1905 until 1915.

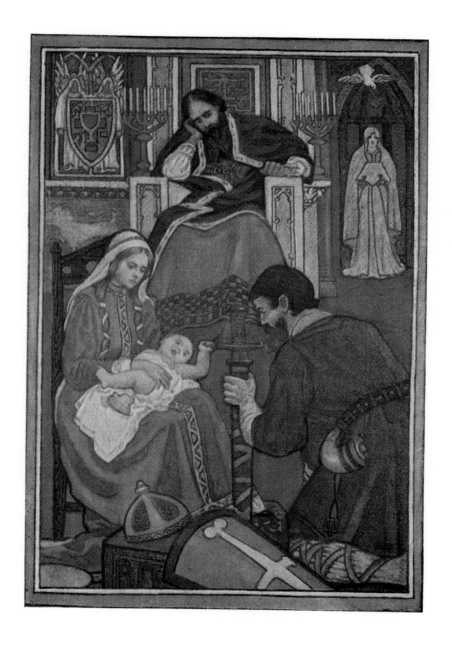

Title page

WILLIAM ERNEST CHAPMAN

Various chapter decorations

WILLIAM ERNEST CHAPMAN

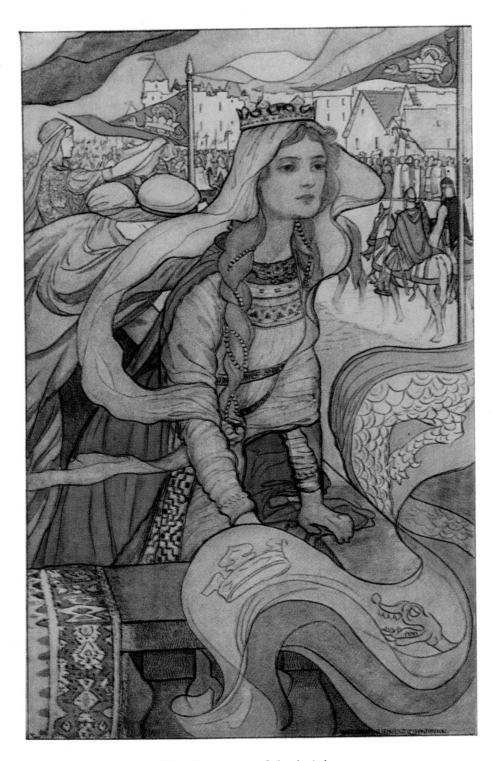

The departure of the knights

WILLIAM ERNEST CHAPMAN

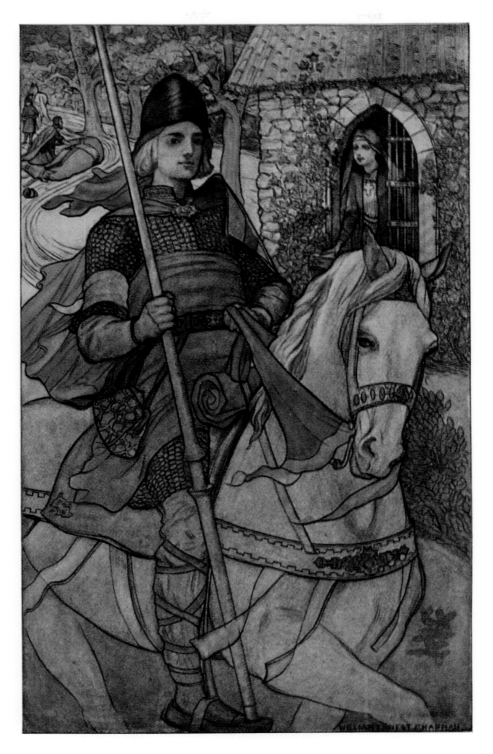

Sir Galahad overthrows Launcelot and Percivale

WILLIAM ERNEST CHAPMAN

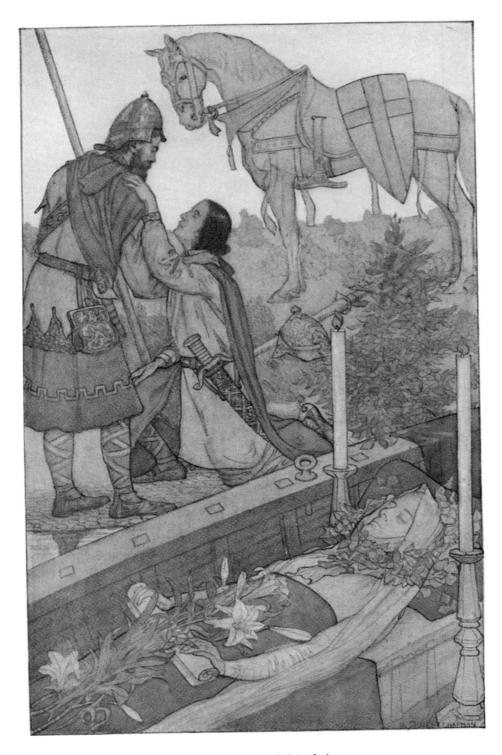

Galahad meets with his father

WILLIAM ERNEST CHAPMAN

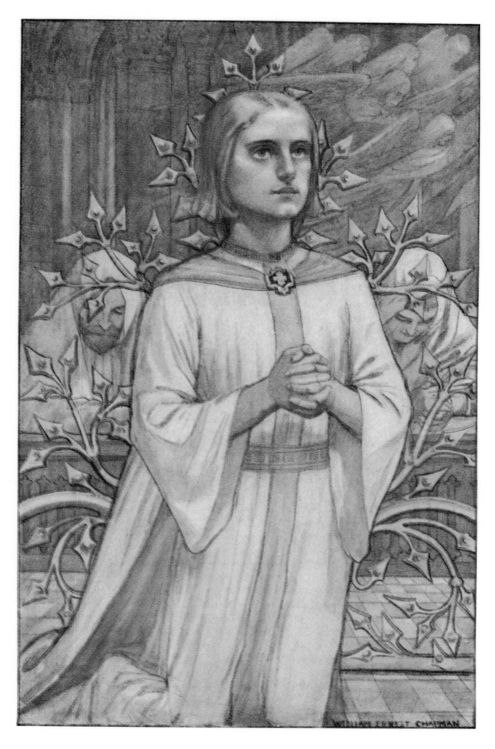

Sir Galahad beholds the Sangreal uncovered

WILLIAM ERNEST CHAPMAN

Young Owen appeals to the King

Walter Crane, 1845–1915
King Arthur's Knights, 1911

Considered one of the forefathers to the English illustrators who dominated the early twentieth century, Walter Crane was one of the few who were accepted in both the illustration and fine-art circles. Working regularly with fairy tales and myths as subject matter, Crane's repeated successes made him one of book illustration's first real "stars"—his name became a selling point for the books he had worked on. Crane took in many influences to form his style, including Medieval and Renaissance works for their symbolism, and Japanese prints for their line and color usage. The Arthurian tales were a natural vessel for Crane's later style, resulting in a set of images both simple and clear in their imagery, taking advantage of the full range of Crane's influences to tell their stories.

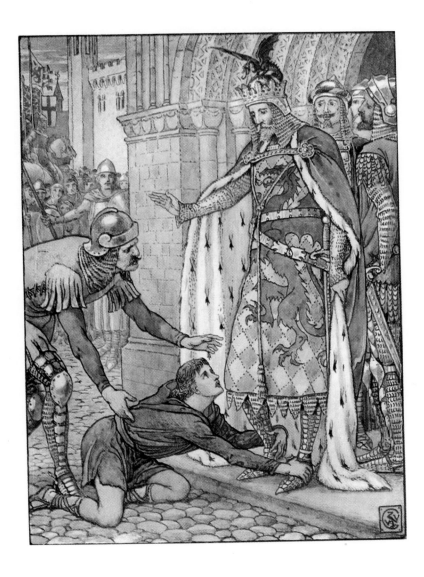

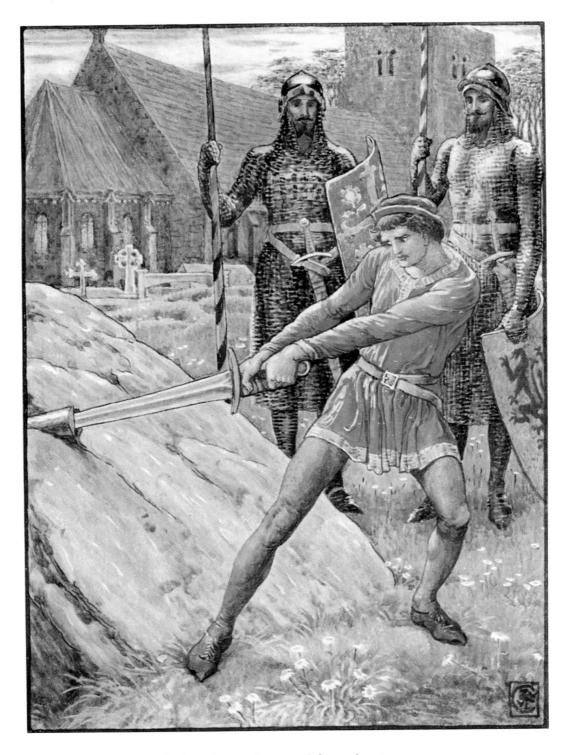

Arthur draws the sword from the stone

WALTER CRANE

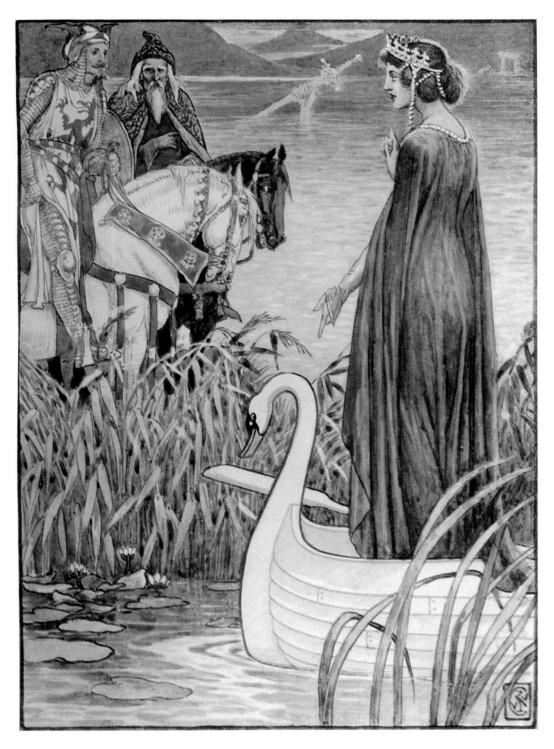

King Arthur asks the Lady of the Lake for the sword Excalibur

WALTER CRANE

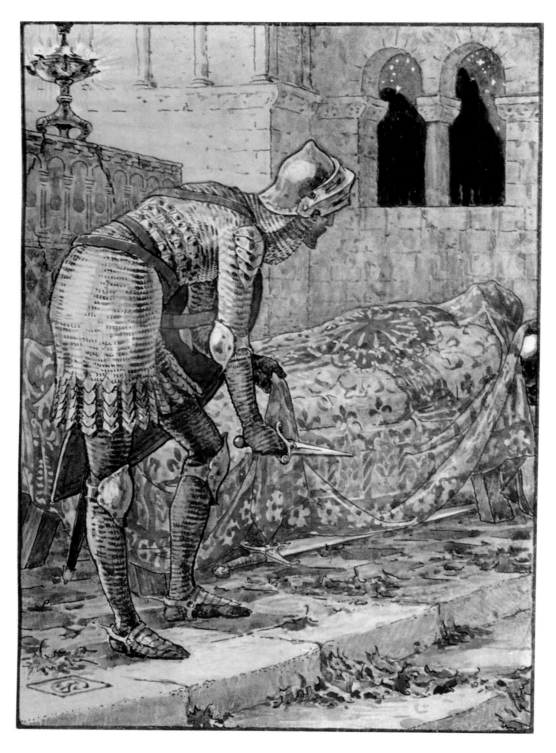

Sir Launcelot in the Chapel Perilous

WALTER CRANE

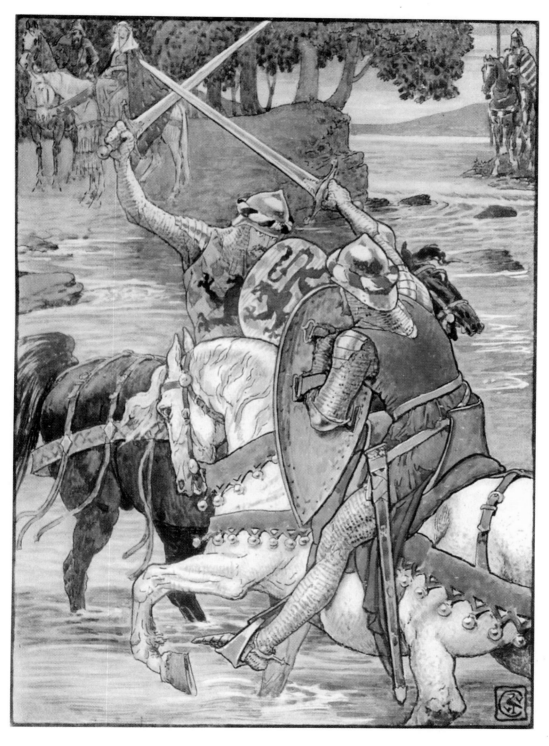

Beaumains wins the fight at the ford

WALTER CRANE

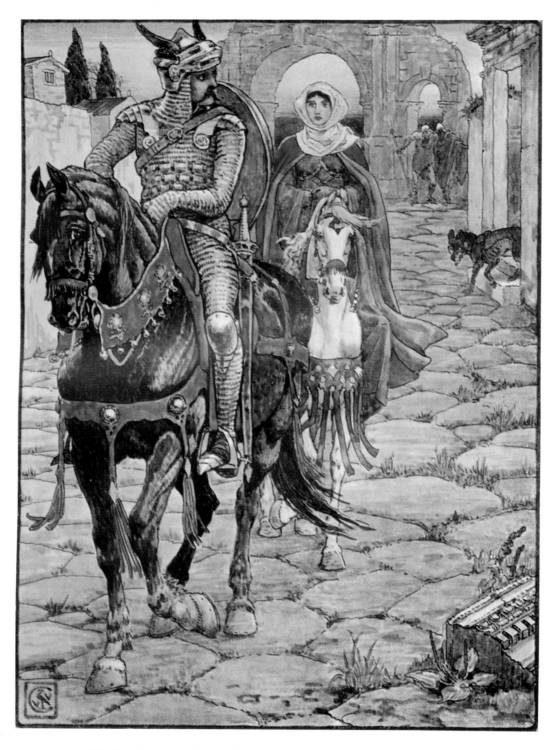

Sir Geraint and the Lady Enid in the deserted Roman town

WALTER CRANE

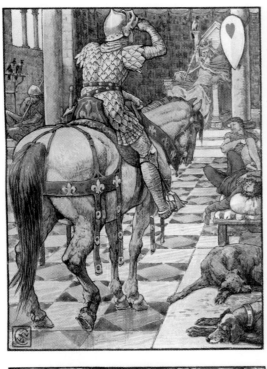
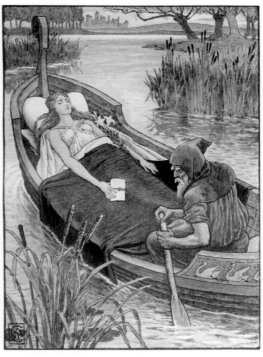
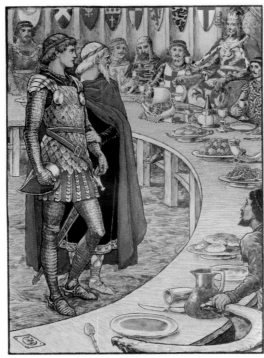
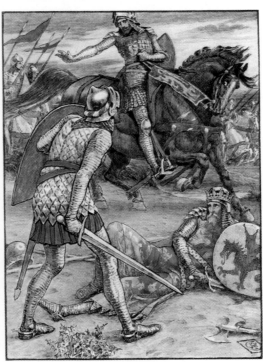

TOP LEFT: Perceval obtains the shield of the beating heart
TOP RIGHT: The Death-journey of the Lily Maid of Astolat
BOTTOM LEFT: Sir Galahad is brought to the court of King Arthur
BOTTOM RIGHT: Sir Lancelot forbids Sir Bors to slay the King

WALTER CRANE

23

"Lo!" said Merlin, "Yonder is that sword that I spake of."
With that they saw a damosel going upon the Lake
Book I, Chapter XXV

WILLIAM RUSSELL FLINT

WILLIAM RUSSELL FLINT, 1880–1969
Le Morte D'Arthur, 1910–11

A British watercolor painter of the first rank, Sir William Russell Flint would become known as an accomplished figurative and landscape artist in the latter part of his career, but his earliest artistic success came in the field of illustration. Apprenticed to a large-scale printer as a teenager, Flint was twenty when illustration—and publishing—really began to mature. With a great deal of Pre-Raphaelite and Victorian influence visible in his subjects and early painting style, Flint took on a number of high-profile titles. Flint's illustration graced editions of such well-known works as *King Solomon's Mines* (1905), *The Odyssey* (1914), and, in 1910 and 1911, Malory's *Le Morte D'Arthur*. The forty-four color plates in the original two-volume set of the work represented a huge undertaking for Flint, and they contain some of the most striking imagery to be found in Arthurian illustration.

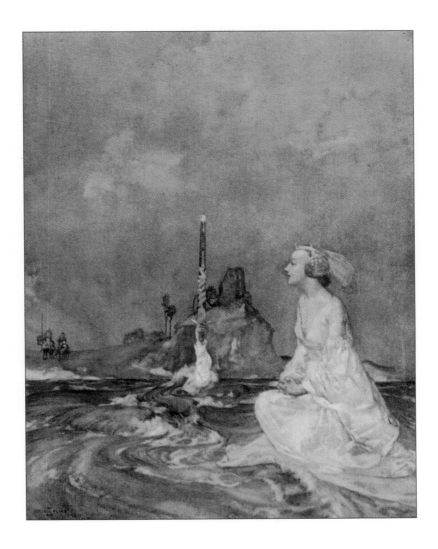

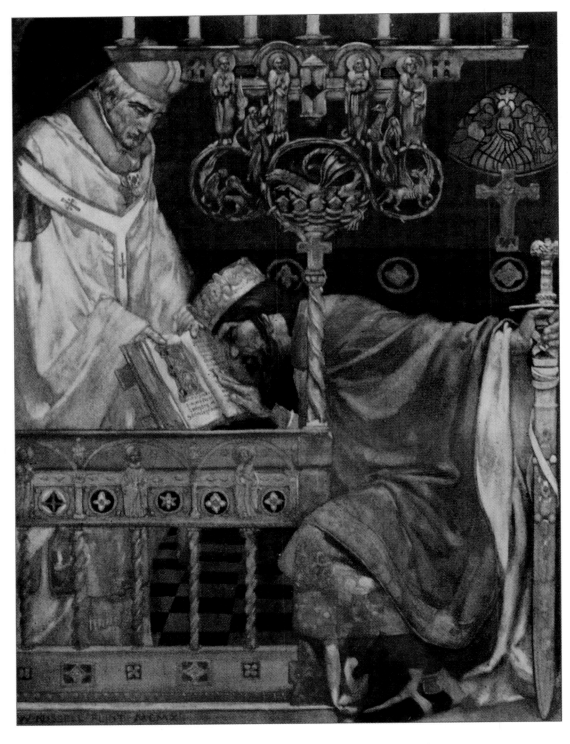

Then the king was sworn upon the four Evangelists
Book I, Chapter II

WILLIAM RUSSELL FLINT

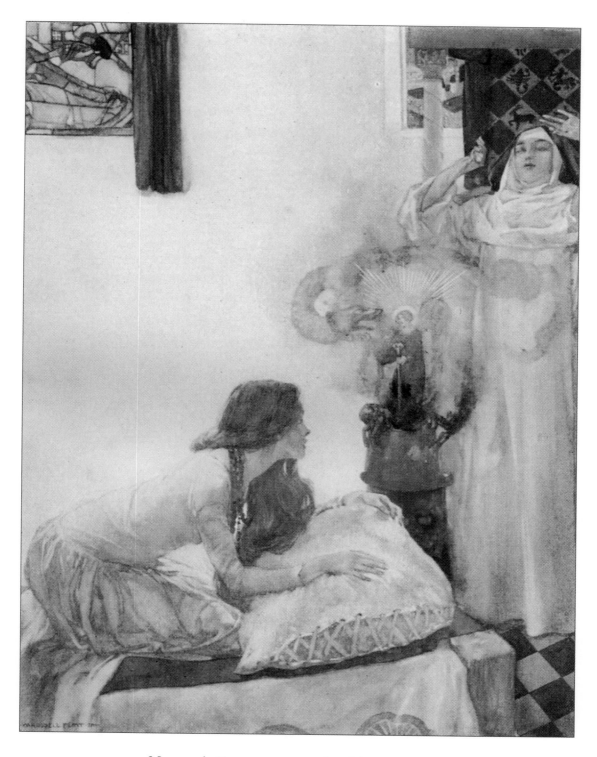

Morgan le Fay was put to school in a nunnery,
and there she learned so much that she was a great clerk of necromancy
Book I, Chapter II

WILLIAM RUSSELL FLINT

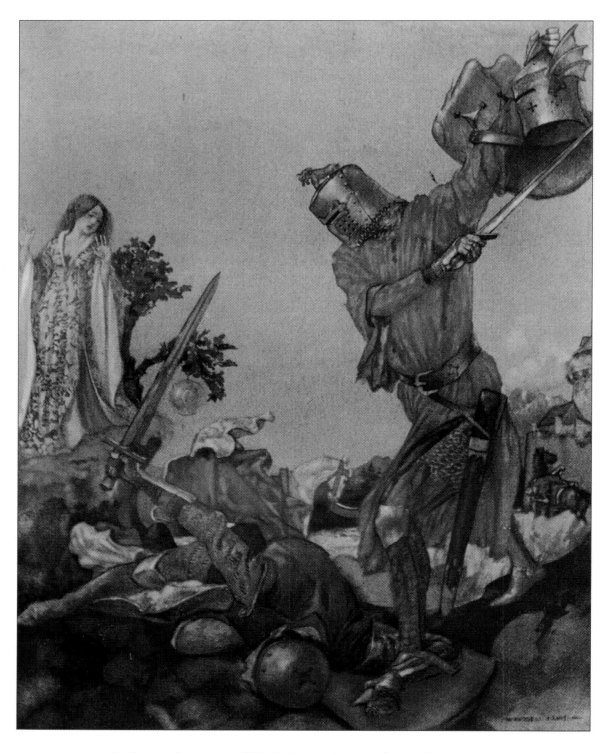

And anon he rased off his helm, and smote his neck in sunder
Book VI, Chapter IX

WILLIAM RUSSELL FLINT

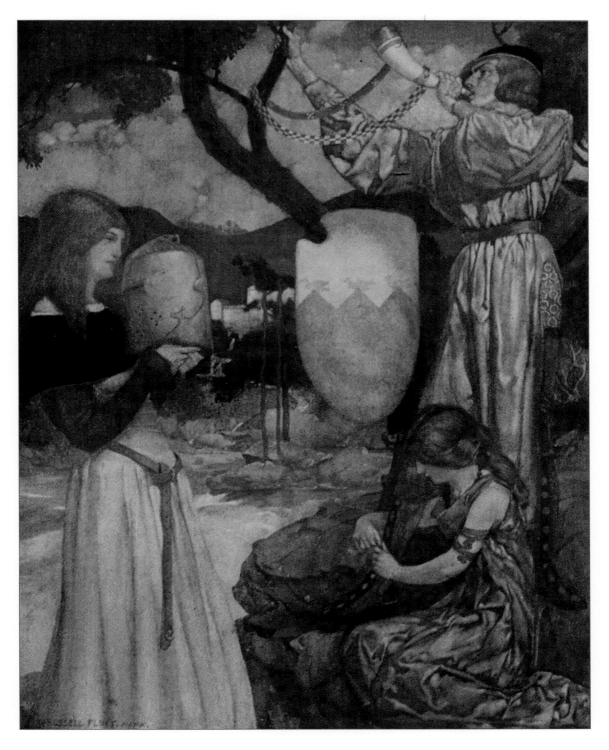

There he blew three deadly notes, and there came two damosels and armed him lightly
Book VII, Chapter VIII

WILLIAM RUSSELL FLINT

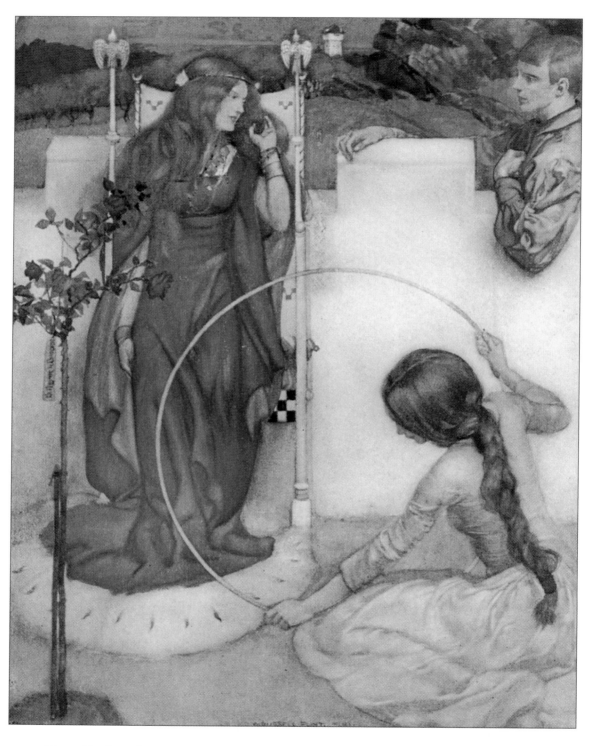

How Sir Gareth, otherwise called Beaumains, came to the presence of his lady,
and how they took acquaintance, and of their love
Book VII, Chapter XXI

WILLIAM RUSSELL FLINT

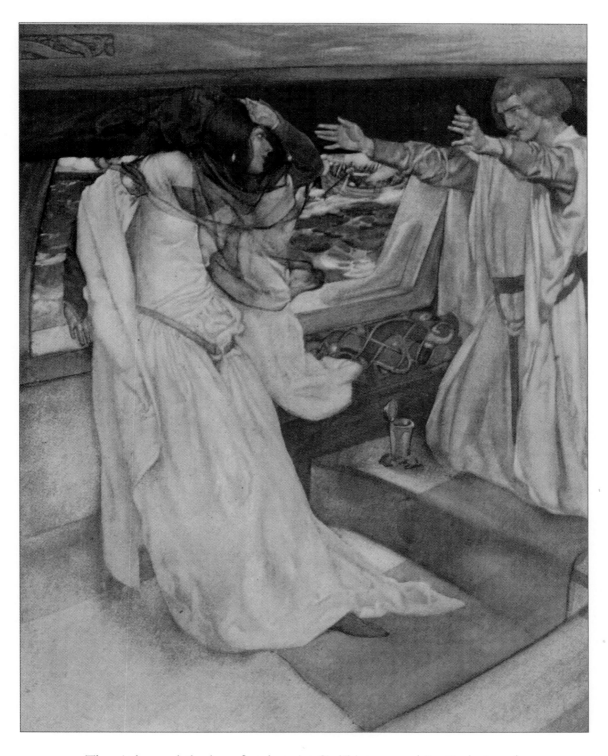

Thus it happed the love first betwixt Sir Tristram and La Beale Isoud,
the which love never departed the days of their life
Book VIII, Chapter XXIV

William Russell Flint

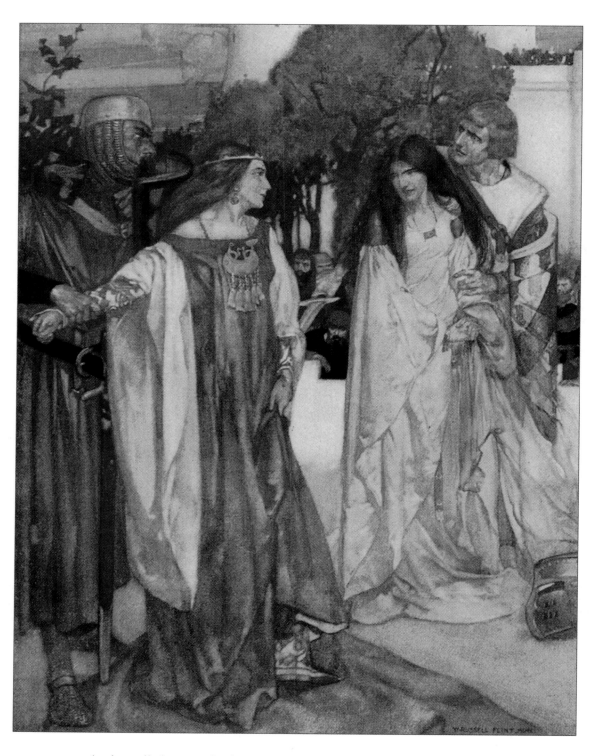

And so all the people that were there present gave judgment that
La Beale Isoud was the fairer lady and the better made
Book VIII, Chapter XXV

WILLIAM RUSSELL FLINT

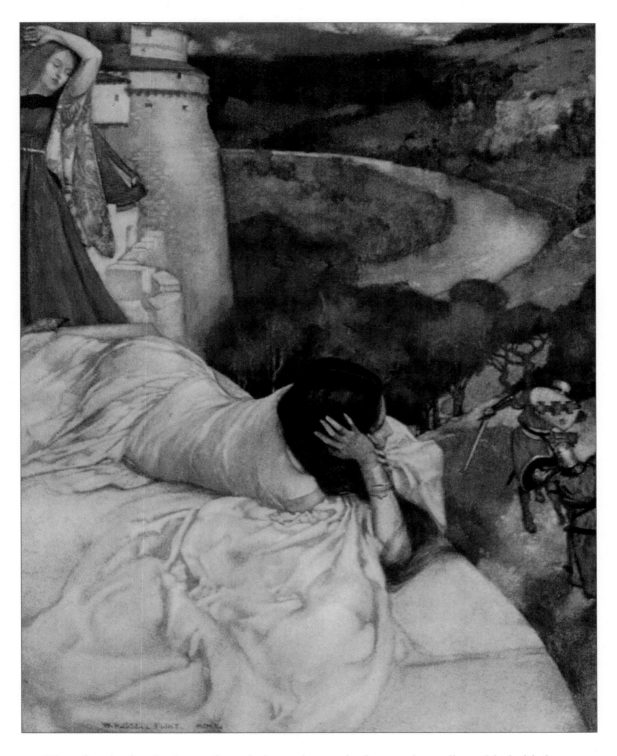

They fought for the love of one lady, and ever she lay on the walls and beheld them
Book VIII, Chapter XXXI

WILLIAM RUSSELL FLINT

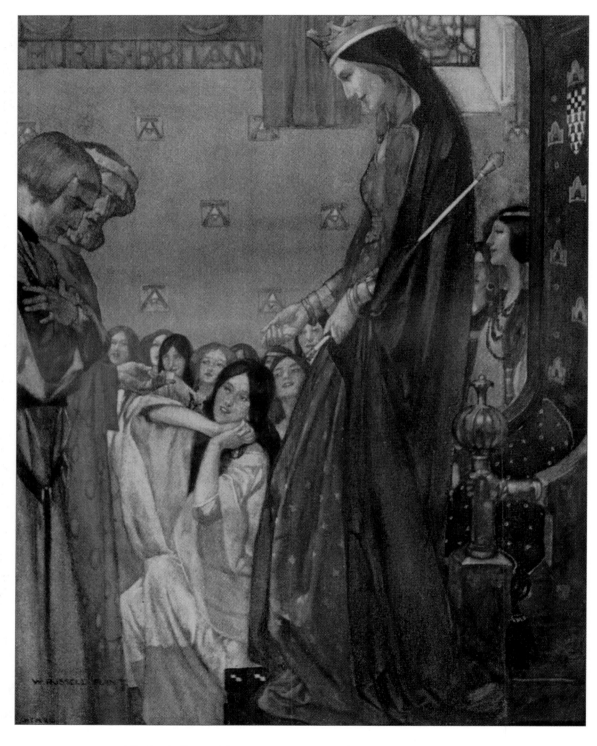

All the ladies said at one voice: "Welcome, Sir Tristram!"
Book X, Chapter VI

WILLIAM RUSSELL FLINT

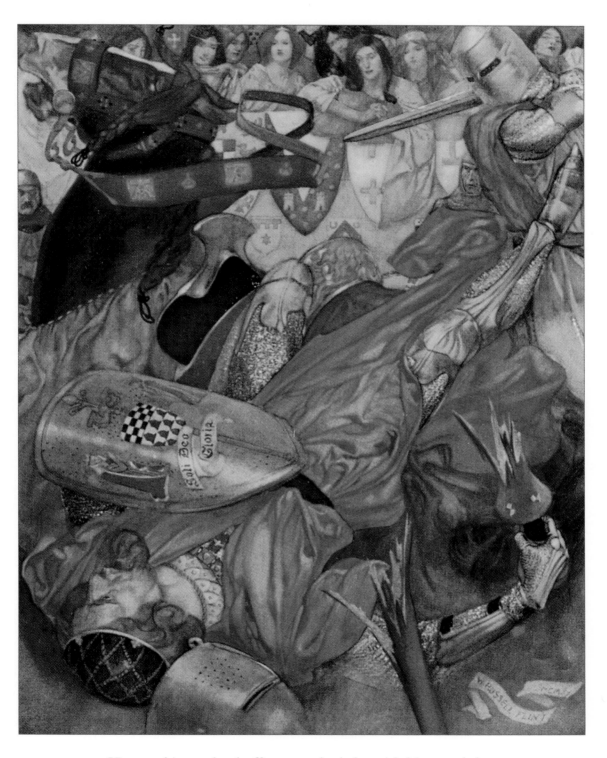

He gave him such a buffet upon the helm with his sword that
King Arthur had no power to keep his saddle
Book X, Chapter LXIX

WILLIAM RUSSELL FLINT

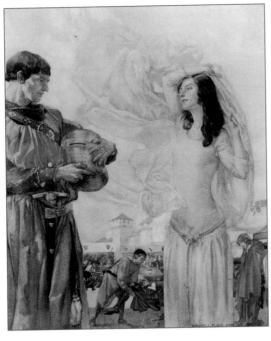
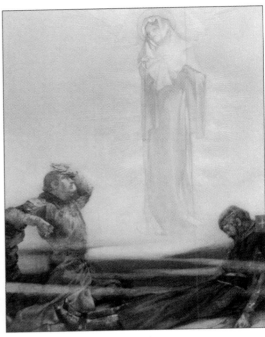
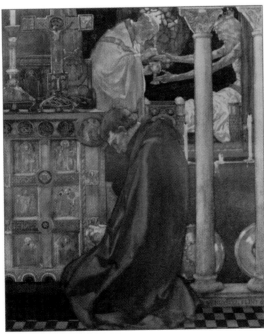
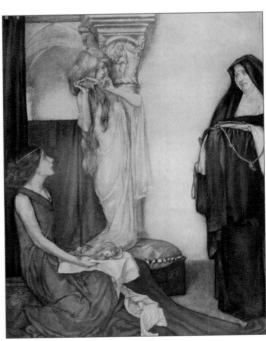

TOP LEFT: Then she unwimpled her visage. And when he saw her he said:
"Here have I found my love and my lady"—*Book X, Chapter XXXIX*
TOP RIGHT: They could not readily see who bare that vessel, but Sir Percivale had
a glimmering of the vessel and of the maiden that bare it—*Book XI, Chapter XIV*
BOTTOM LEFT: When the mass was done the priest took Our Lord's body
and bare it to the sick king—*Book XIV, Chapter III*
BOTTOM RIGHT: "As soon as I wist that this adventure was ordained me I clipped off
my hair, and made this girdle in the name of God"—*Book XVII, Chapter VII*

WILLIAM RUSSELL FLINT

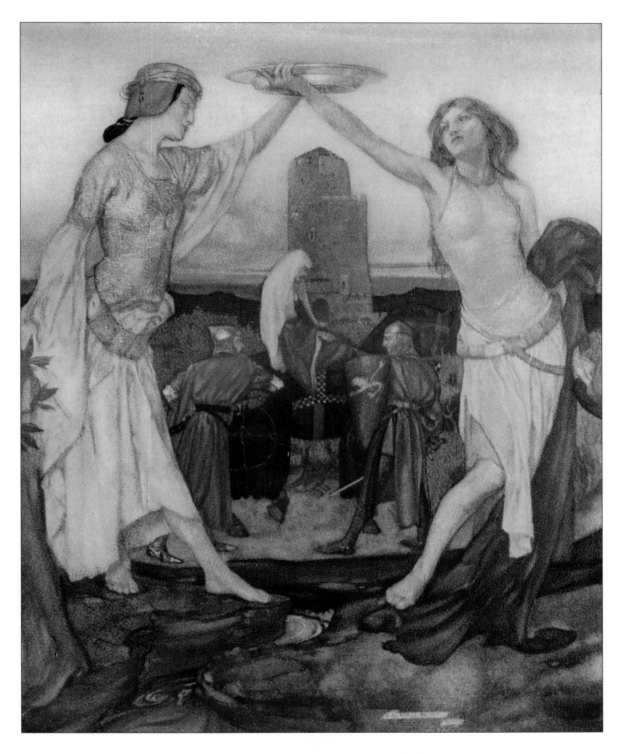

"Sir," said a knight, "what maid passeth hereby
shall give this dish full of blood of her right arm"
Book XVII, Chapter X

WILLIAM RUSSELL FLINT

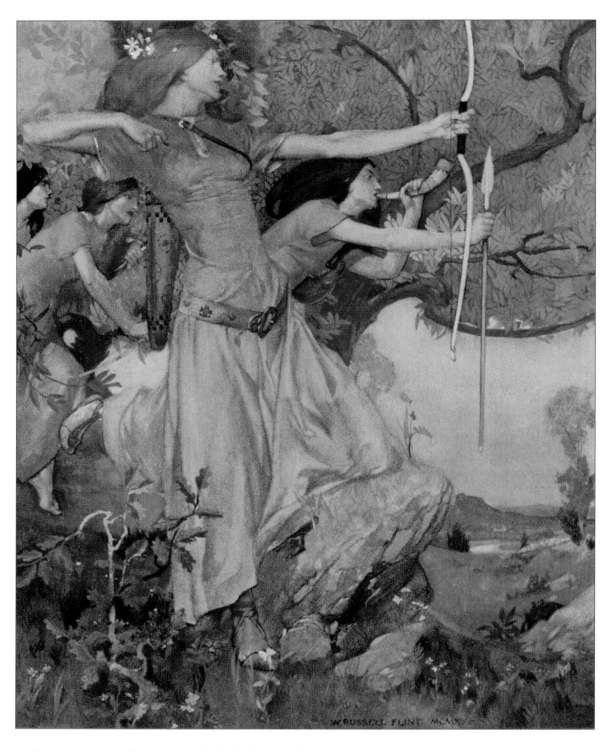

She was a great huntress and daily she used to hunt, and ever she bare her bow with her
Book XVIII, Chapter XXI

WILLIAM RUSSELL FLINT

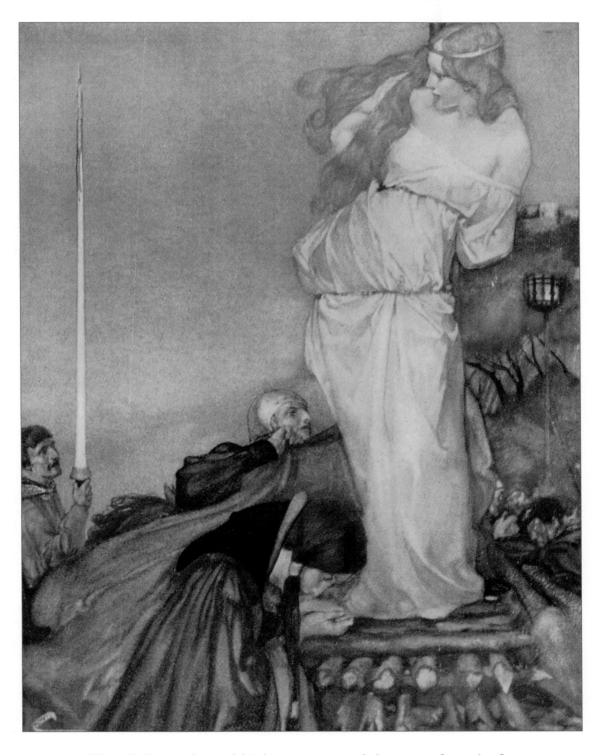

How Sir Launcelot and his kinsmen rescued the queen from the fire
Book XX, Chapter VIII

WILLIAM RUSSELL FLINT

Lancelot brings Guenevere to Arthur

H. J. FORD

H. J. FORD, 1860–1940
The Book of Romance, 1902

If there is any common ground between Pre-Raphaelite painters and book illustrators in Victorian England, H. J. Ford belongs on that terrain. At the end of the nineteenth century, black-and-white line art was still the dominant vehicle for illustration, and H. J. Ford was creating scores of beautiful pieces for dozens of children's books. He would later do color work as well, but his skillful use of pen and ink is the reason for his being remembered today. Not only was Ford remarkably prolific during the prime period of his career, but he was also able to maintain a consistent level of high quality in his work. A long partnership with prominent folk and fairy tale historian Andrew Lang enabled Ford to be productive for the better part of two decades, yielding over eighteen collaborative titles. The work Ford produced for Lang's *Red Book of Romance* contained a fair share of Arthurian stories, and the wide distribution of this edition made his images some of the best known to both American and English audiences.

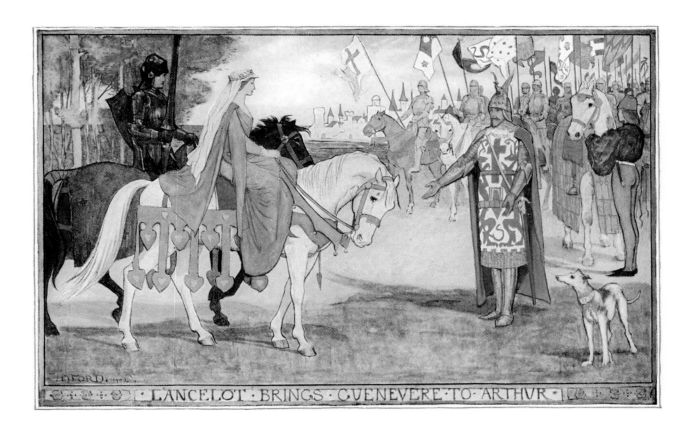

LANCELOT·BRINGS·GUENEVERE·TO·ARTHUR

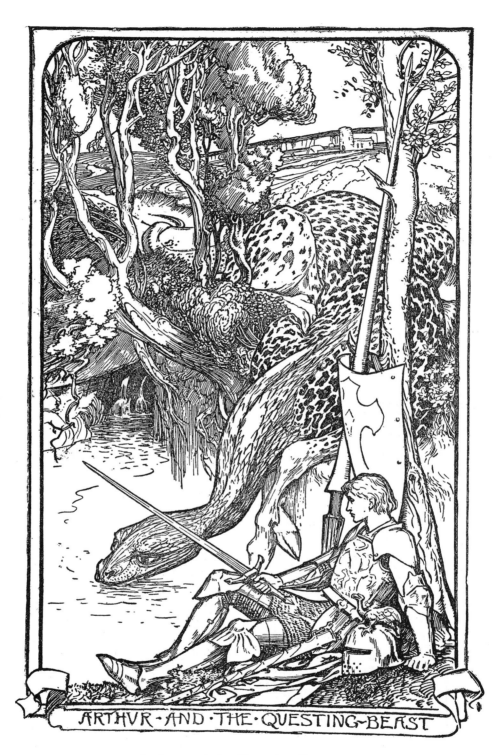

Arthur and the Questing Beast

H. J. FORD

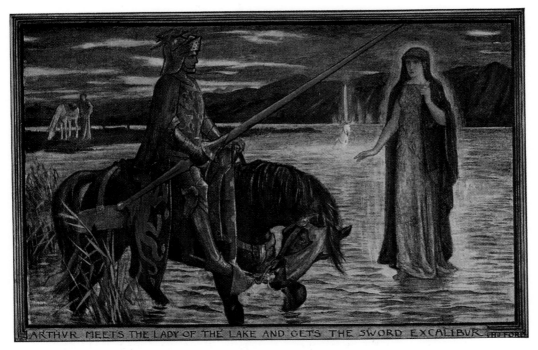

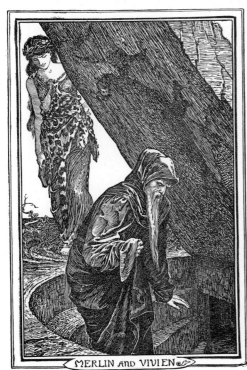

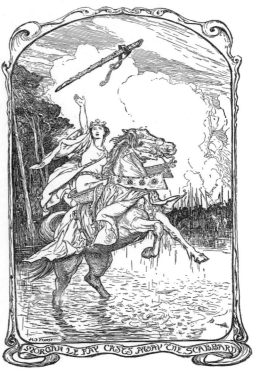

TOP: Arthur meets the Lady of the Lake and gets the sword Excalibur
BOTTOM LEFT: Merlin and Vivien
BOTTOM RIGHT: Morgan le Fay casts away the scabbard

H. J. FORD

43

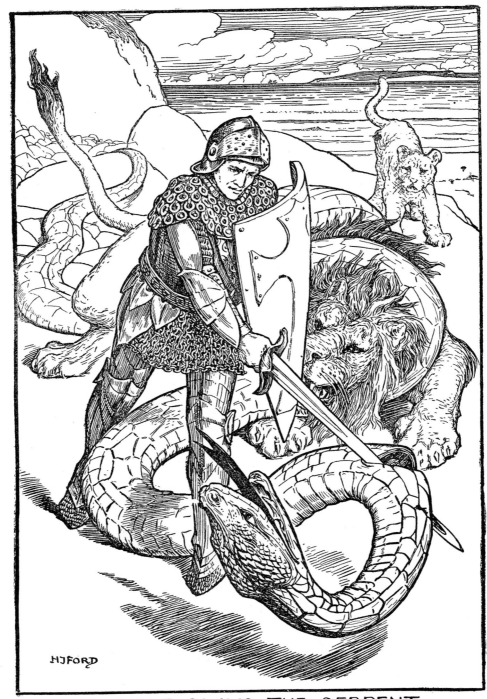

SIR PERCIVALE SLAYS THE SERPENT

Sir Percivale slays the Serpent

H. J. FORD

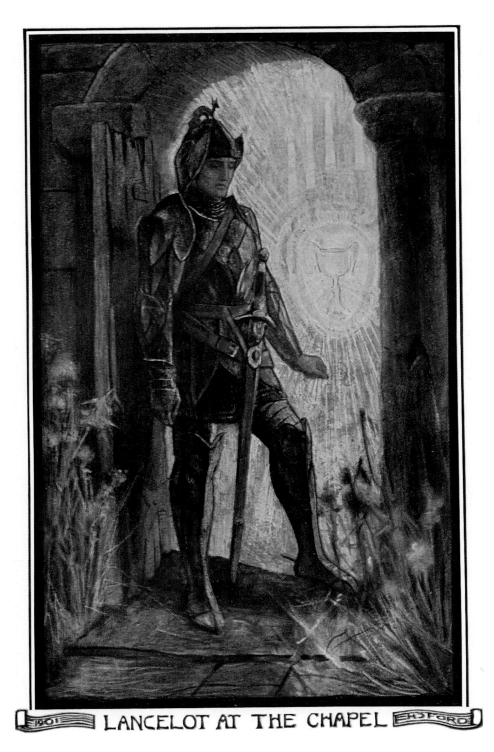

Lancelot at the Chapel

H. J. FORD

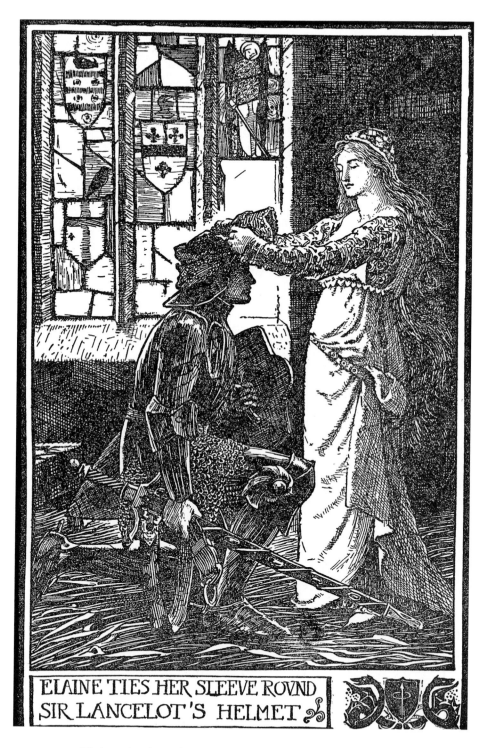

Elaine ties her sleeve round Sir Lancelot's Helmet

H. J. FORD

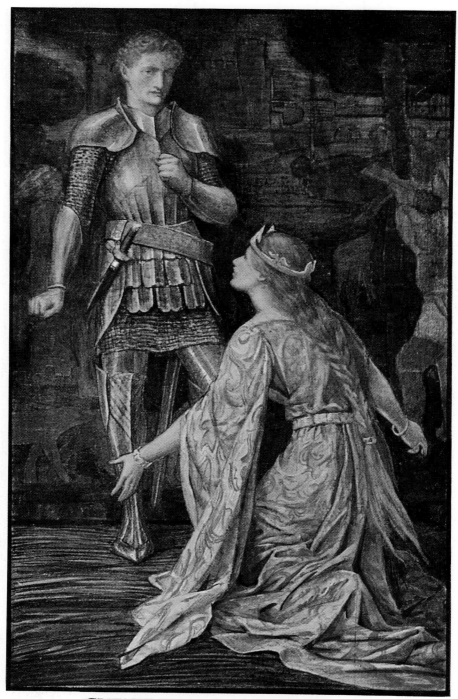

GVENEVERE & SIR BORS

Guenevere and Sir Bors

H. J. Ford

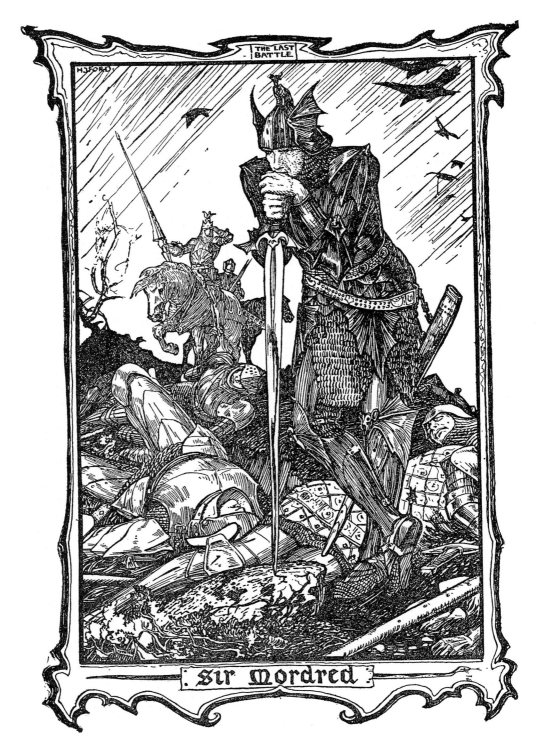

Sir Mordred: The Last Battle

H. J. Ford

48

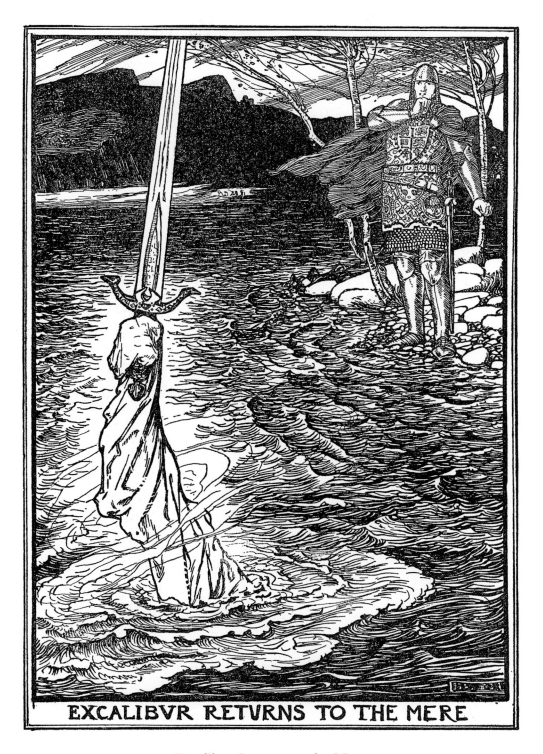

EXCALIBVR RETURNS TO THE MERE

Excalibur Returns to the Mere

H. J. FORD

The Lady of the Lake

THOMAS MACKENZIE

THOMAS MACKENZIE, 1887–1944
Arthur and his Knights, 1920

A number of gifted illustrator–designers followed the Golden Age of Illustration into the Art Deco period. Thomas Mackenzie was one of the best of these artists, remaining loyal to the goals of his illustration work, while producing a visual style that matched the taste of the day. This Arthurian tale, appearing in 1920, was Mackenzie's first commissioned book. Often compared to Harry Clarke and Aubrey Beardsley for his stylized work, Mackenzie achieved greater success with color, producing palettes both rich and sensitive and owing much to the influence of Japanese prints.

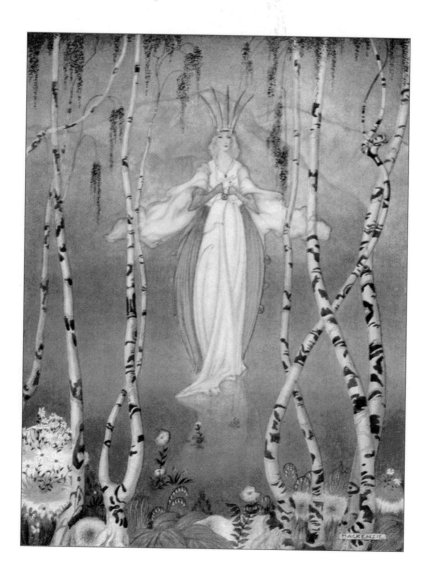

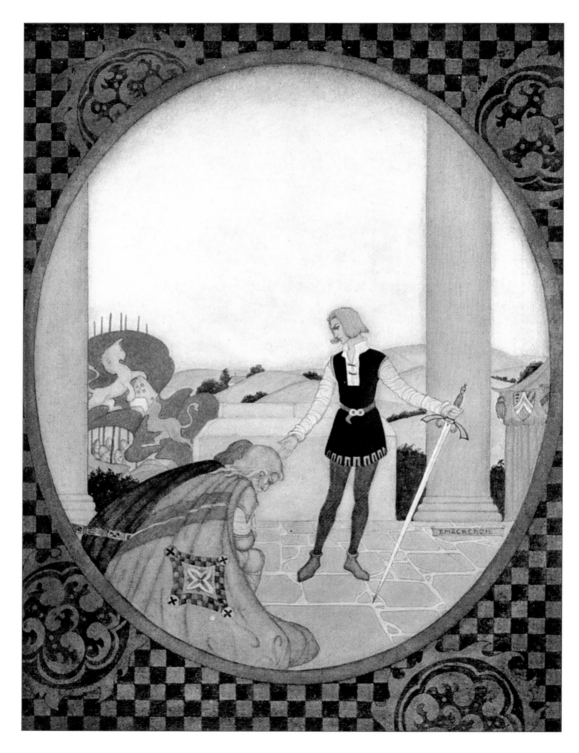

They hailed him as the King of England

THOMAS MACKENZIE

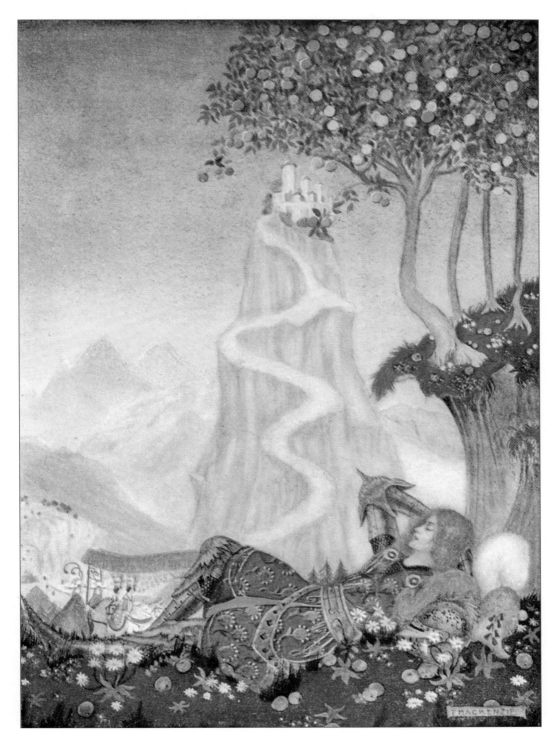

Lancelot lay sleeping under the apple tree

THOMAS MACKENZIE

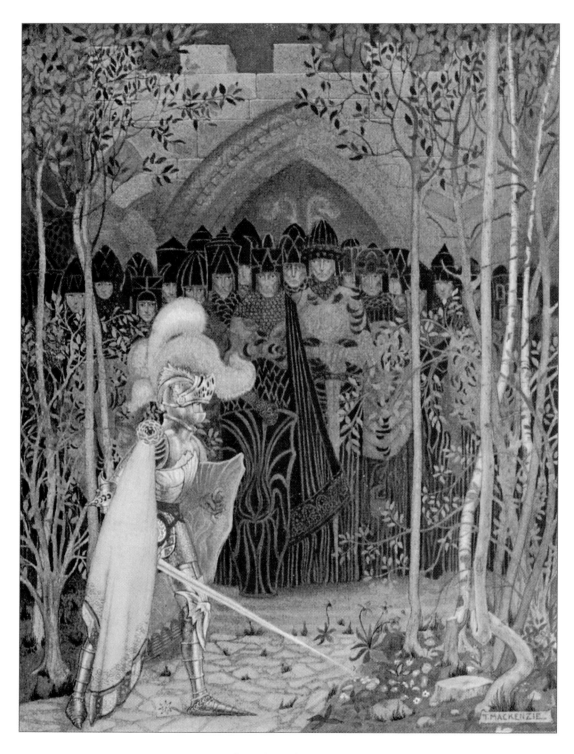

The Chapel Perilous

THOMAS MACKENZIE

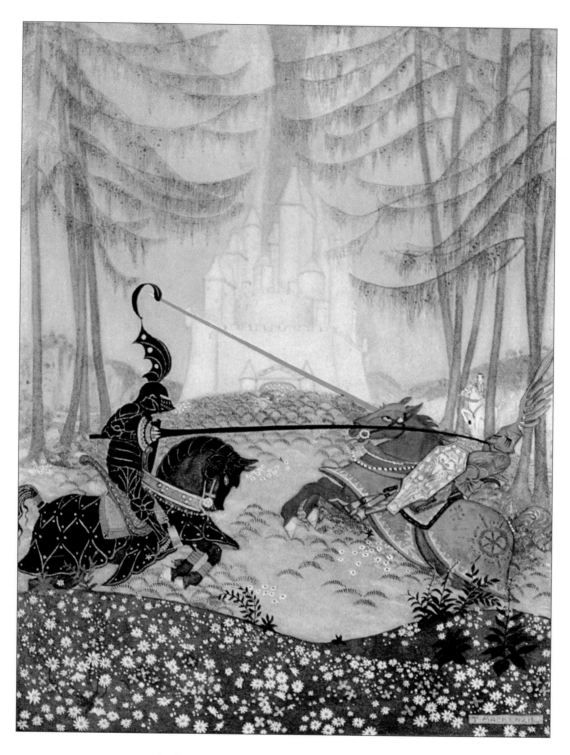

At last Gareth overcame the Red Knight

Thomas Mackenzie

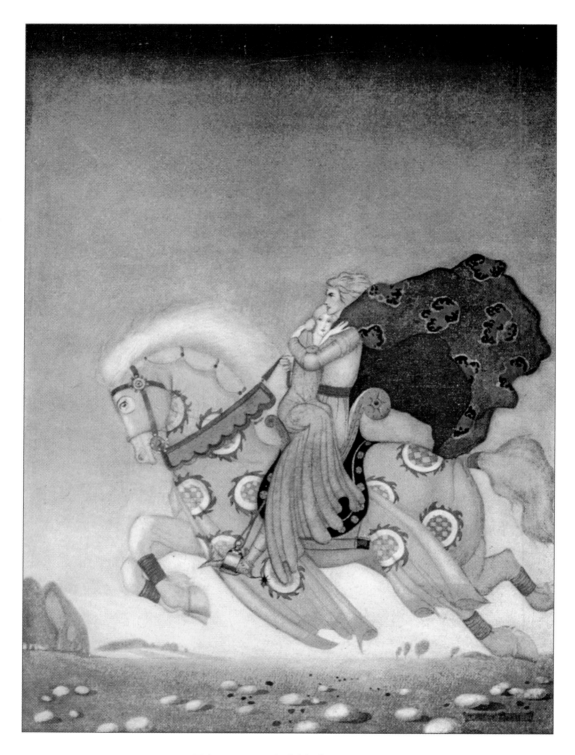

Tristram carried his love away

Thomas Mackenzie

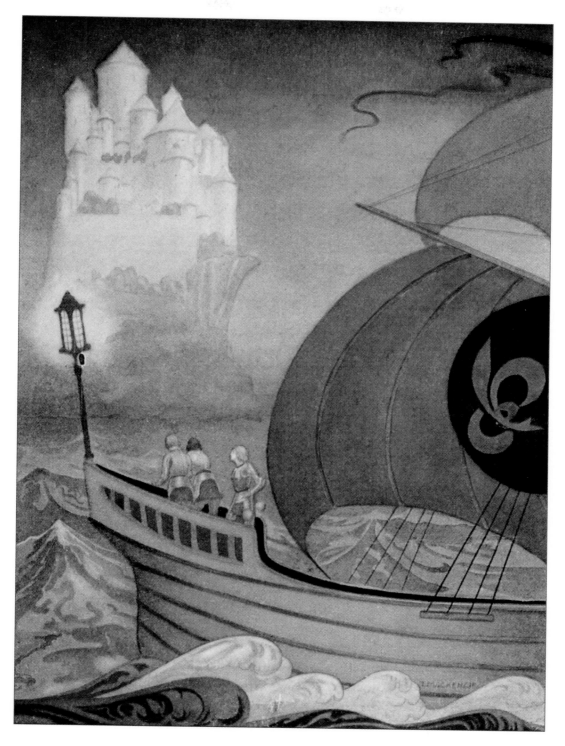

A castle was in sight, built close by the sea

THOMAS MACKENZIE

Half-title art

WILLY POGÁNY

WILLY POGÁNY, 1882–1955
Parsifal, 1912

Born in rural Hungary, Pogány was one of the most successful illustrators of the Golden Age to come to America via London. Pogány, settling in London at the age of twenty-three, courted Europe's largest publishers. By 1907, he had begun to find steady work in children's book illustration. He spent the next eight years producing images for the British book market, both children's and adult. What are largely considered to be his masterworks in illustration are four volumes produced between 1910 and 1913. These rich volumes combine calligraphic text pages with full and partial pages of line art on neutral-toned papers; they feature full-color plates as well. Following Pogány's *Rime of the Ancient Mariner* in 1910 were images for a trilogy of Wagnerian epics—the middle title being *Parsifal*—in 1912. After immigrating to America in 1915, Pogány continued working in book illustration, adding stage and set design, mural work, and portraiture to an already impressive résumé.

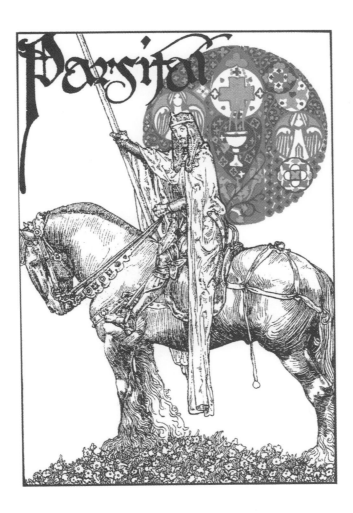

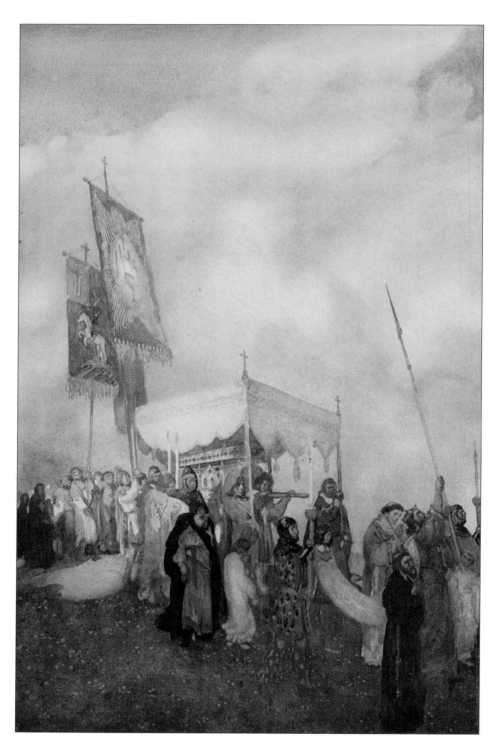

And so they search'd, until
Upon the east slope of a sun-kissed hill
They found a ruin'd shrine

W<small>ILLY</small> P<small>OGÁNY</small>

So here the good king knew the place assign'd
To be the Grail's high court and sanctuary

WILLY POGÁNY

. . . He mounted his rough steed, and forth, alone
Into the shadowy wood he took his way

Willy Pogány

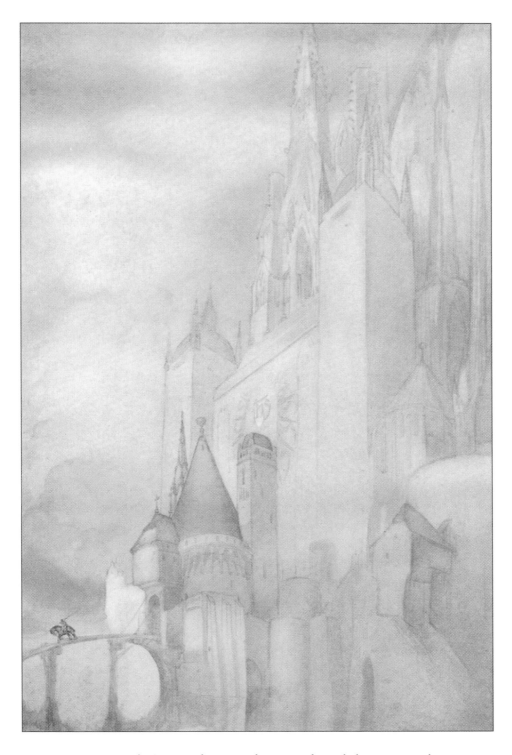

. . . Wondering, and sore at heart, at length he mounted,
and crossed o'er the lowered drawbridge

WILLY POGÁNY

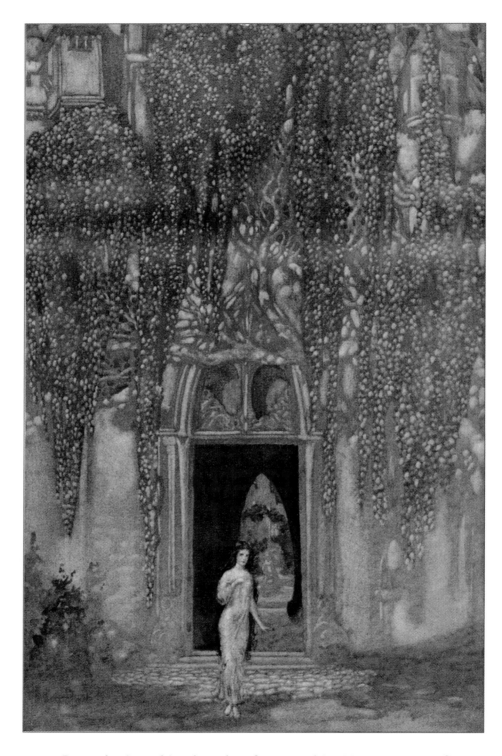

. . . Beneath o'erarching boughs of moon-white May, even as at first,
he saw before him stand
The Lady of the Forest

WILLY POGÁNY

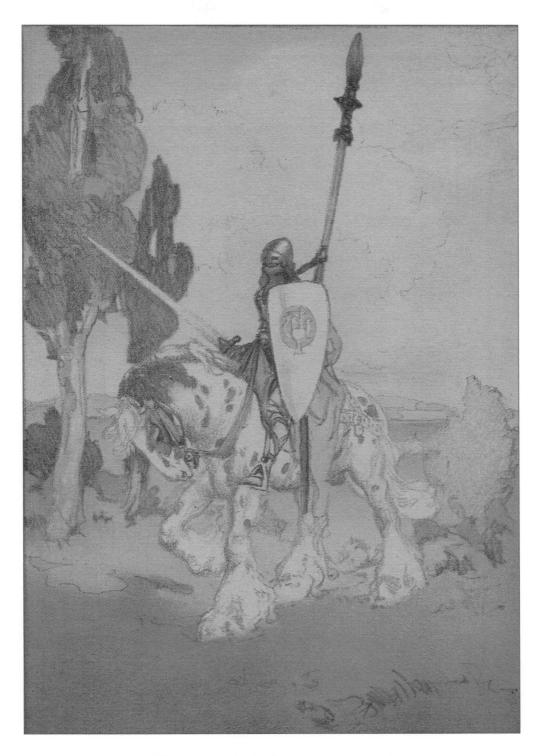

When through the bourgeoning wood
They saw the gleam of armour, and a knight . . .
rode into sight

WILLY POGÁNY

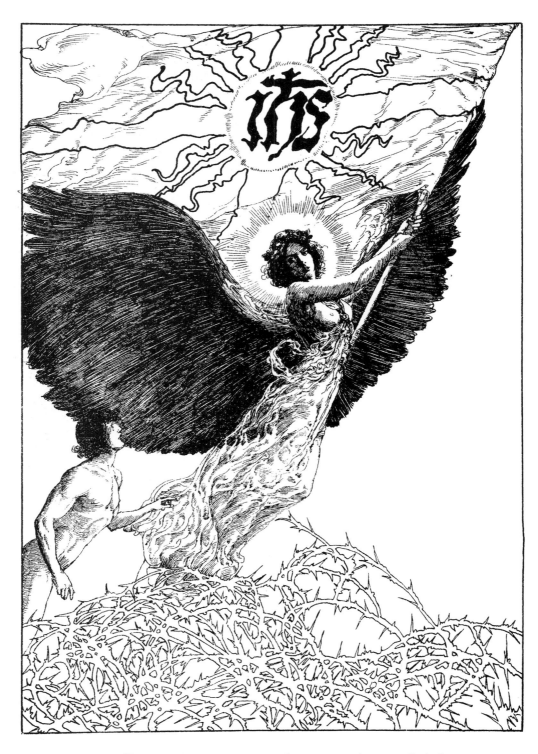

. . . But powers more strong than we are have unfurled
The flag that thou must follow through the world

WILLY POGÁNY

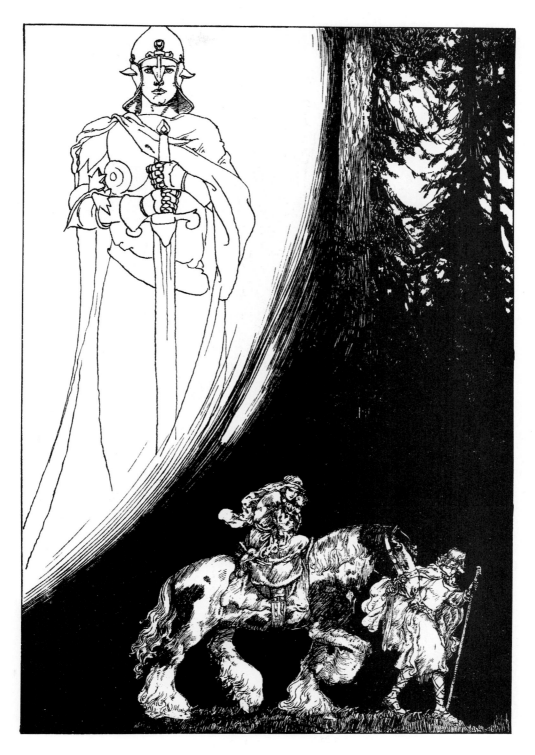

. . . Thy father fell in battle, and the same stern lot befell thy brethren;
but with thee, a little babe, thy mother secretly
Fled from her lordly castle

WILLY POGÁNY

Full-page line decoration

WILLY POGÁNY

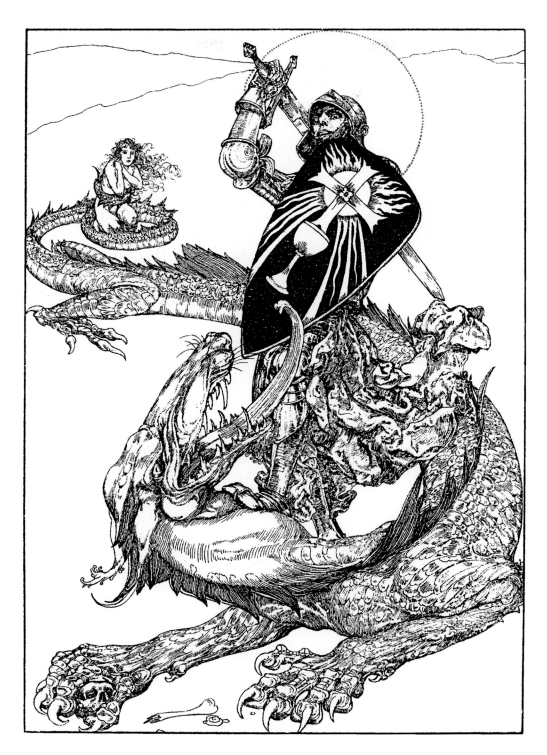

. . . Or oftentimes if haplesss child or maid
Cried in great anguish for immortal aid
There stood to succor them a Shining One . . .

WILLY POGÁNY

King Arthur of Britain
The Story of King Arthur and his Knights

HOWARD PYLE

HOWARD PYLE, 1853–1911
The Story of King Arthur and his Knights, 1903
The Story of the Champions of the Round Table, 1905
The Story of Sir Launcelot and his Companions, 1907
The Story of the Grail and the Passing of Arthur, 1910

For a quarter of a century, Howard Pyle was, by most accounts, the foremost children's book and magazine illustrator in America. After his early line work appeared in magazines such as *St. Nicholas* and *Harpers Monthly,* book commissions began to come in, and Pyle's subjects began to mature as well. While maintaining work in children's materials throughout his career, Pyle went on to illustrate stories for the top magazines and books of the day. Pyle specialized in stories of colonial America, pirates and the age of sail, and medieval tales. In 1902, Pyle began to illustrate and write his own version of the Arthurian tales, working on four volumes of stories over the next eight years. The four books that he produced contained scores of strong full-page line pieces, as well as decorations and illustrated initials; these have remained in print for a century. Pyle is also well remembered for founding the Brandywine School of American Illustration, shaping many of the next generation's finest illustrators.

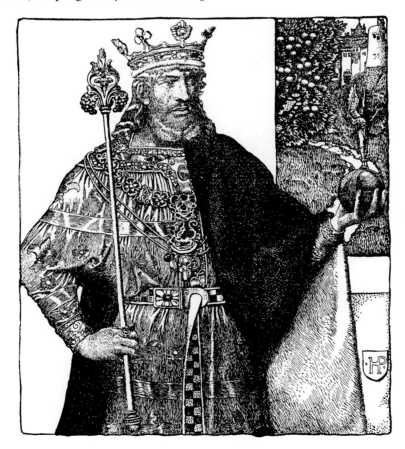

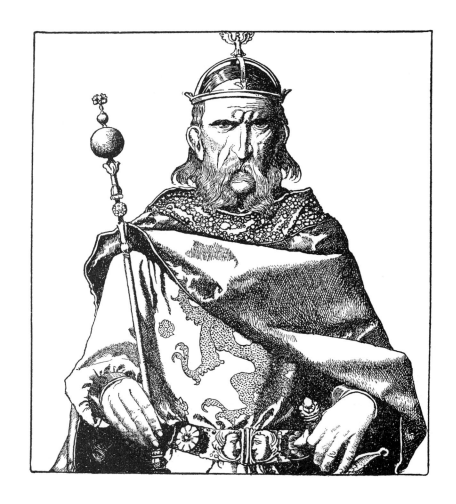

TOP: Uther-Pendragon
BOTTOM: Chapter-head decoration
The Story of King Arthur and his Knights

HOWARD PYLE

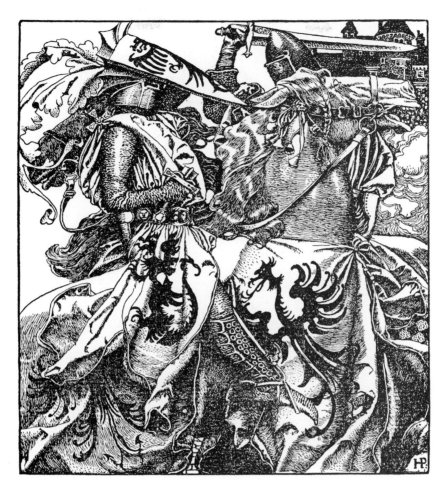

Top: Sir Kay breaketh his sword at the tournament
Bottom: Chapter-head decoration
The Story of King Arthur and his Knights

HOWARD PYLE

73

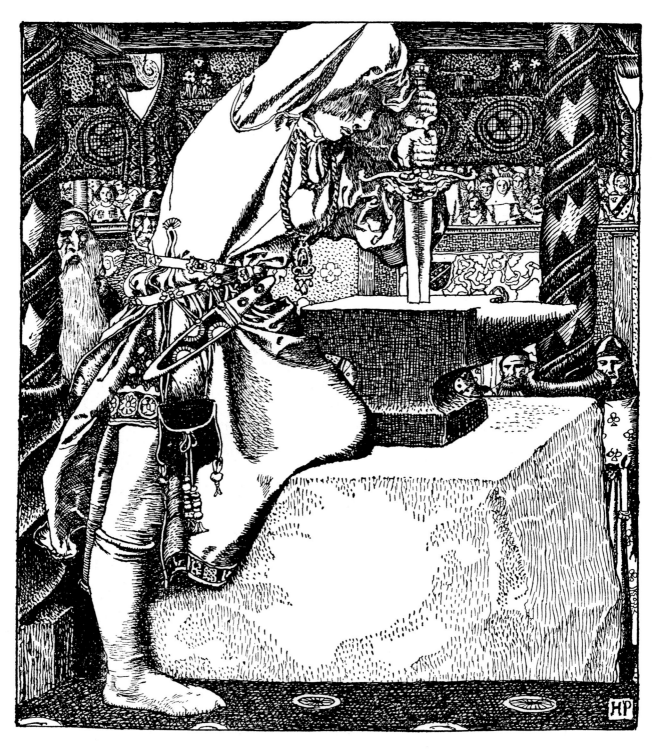

How Arthur drew forth the sword
The Story of King Arthur and his Knights

HOWARD PYLE

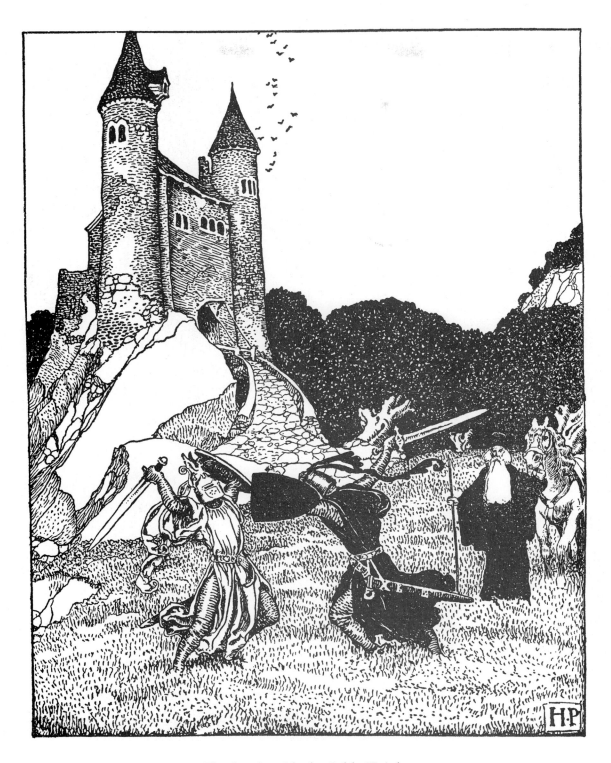

The battle with the Sable Knight
The Story of King Arthur and his Knights

HOWARD PYLE

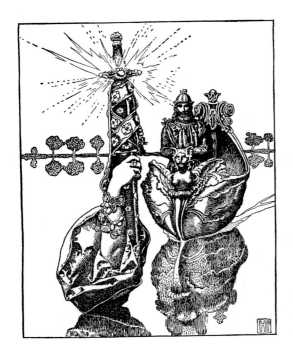

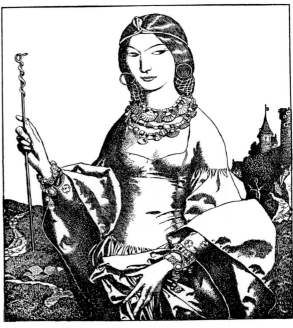

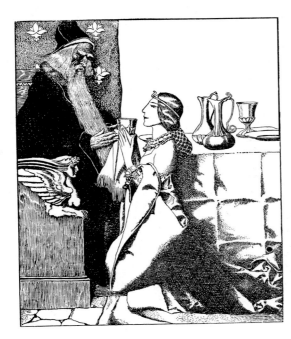

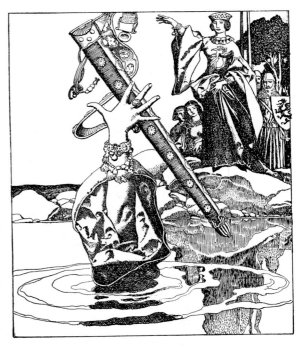

TOP LEFT: Excalibur the Sword
TOP RIGHT: The Enchantress Vivien
BOTTOM LEFT: Vivien bewitches Merlin
BOTTOM RIGHT: Queen Morgana loses Excalibur his sheath
The Story of King Arthur and his Knights

HOWARD PYLE

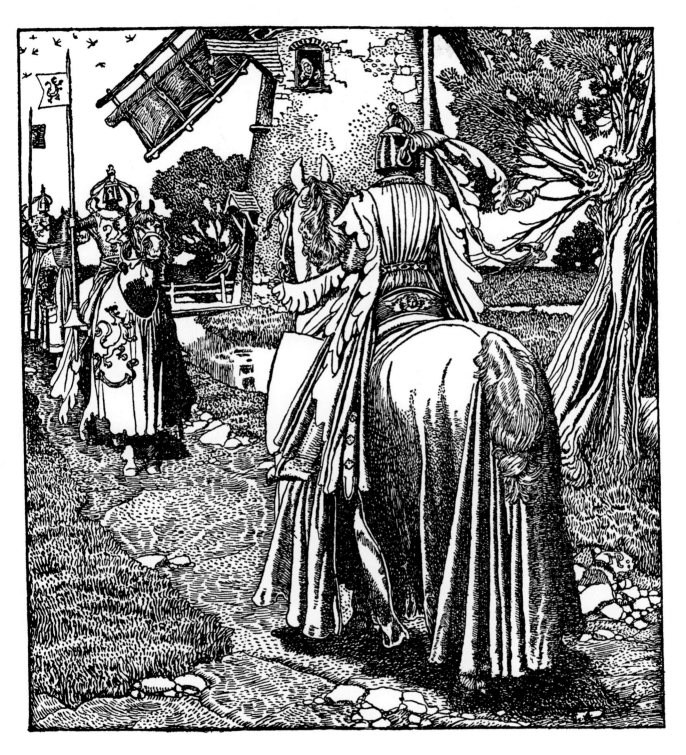

The White Champion meets two knights at the mill
The Story of King Arthur and his Knights

HOWARD PYLE

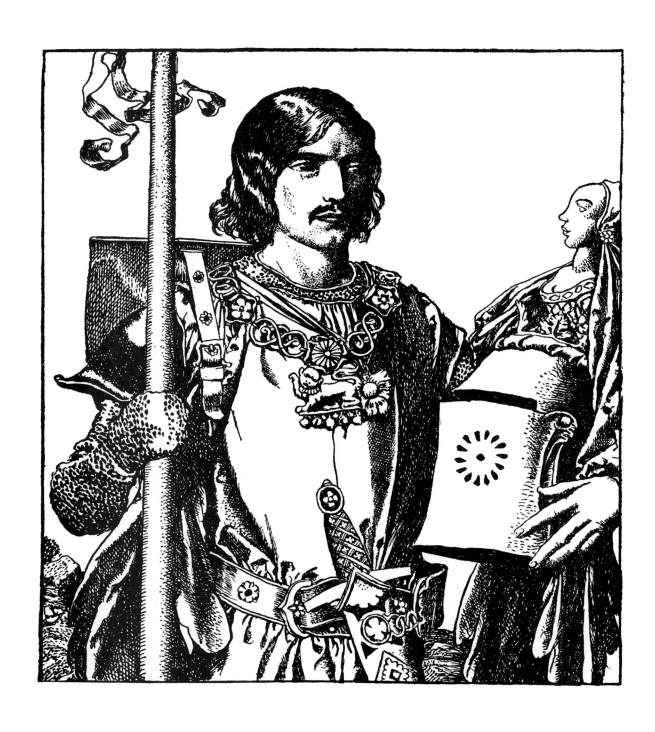

Sir Launcelot of the Lake
The Story of the Champions of the Round Table

HOWARD PYLE

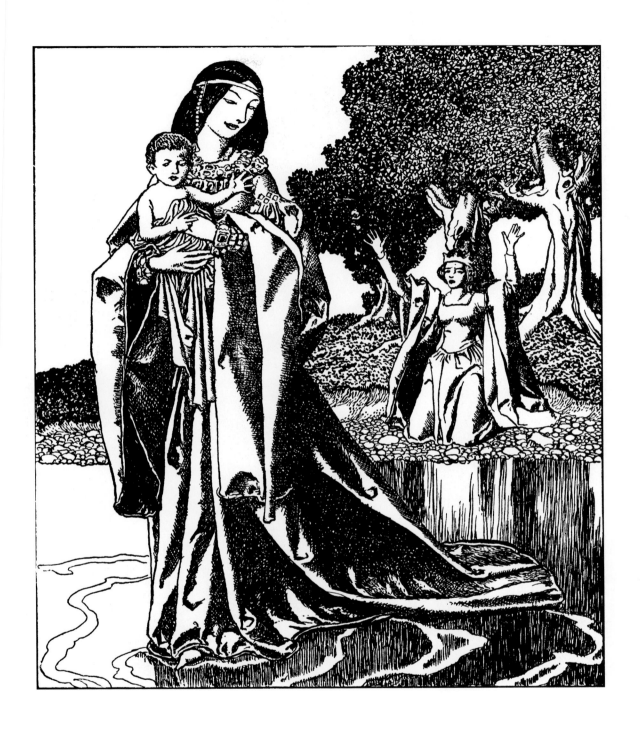

The Lady Nymue beareth away Launcelot into the lake
The Story of the Champions of the Round Table

HOWARD PYLE

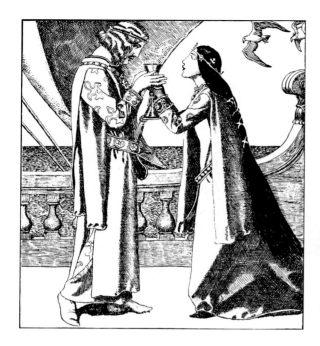
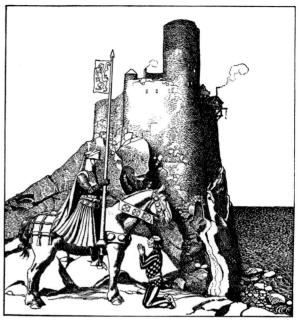
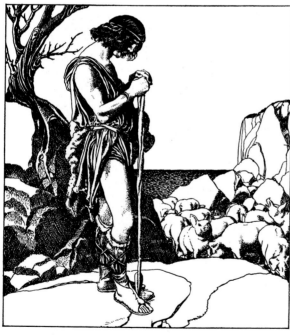

Top Left: Belle Isoult and Sir Tristram drink the love draught
Top Right: Sir Tristram cometh to the castle of Sir Nabon
Bottom Left: Sir Lamorack herds the swine of Sir Nabon
Bottom Right: Sir Kay interrupts the meditations of Sir Percival
The Story of the Champions of the Round Table

Howard Pyle

80

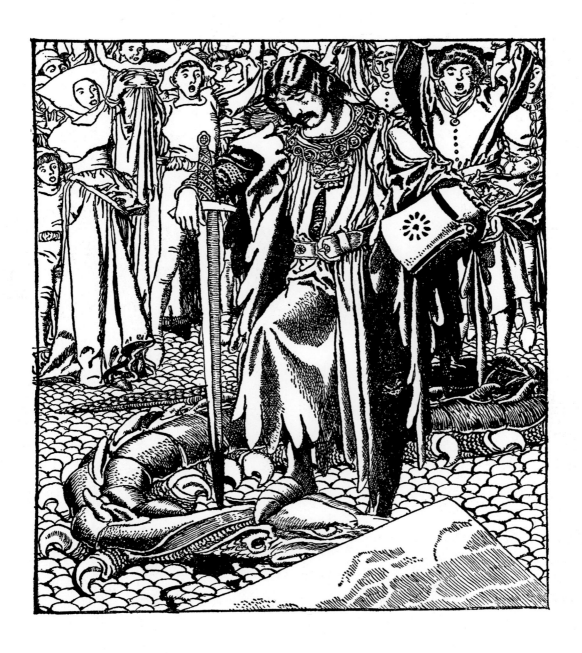
Sir Launcelot slayeth the Worm of Corbin
The Story of Sir Launcelot and his Companions

HOWARD PYLE

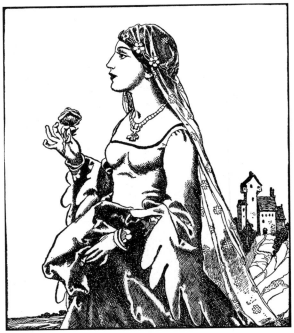

Top: Chapter-head decoration
Bottom Left: Sir Gareth doeth Battle with the knight of the river ford
Bottom Right: The Lady of the Fountain
The Story of Sir Launcelot and his Companions

Howard Pyle

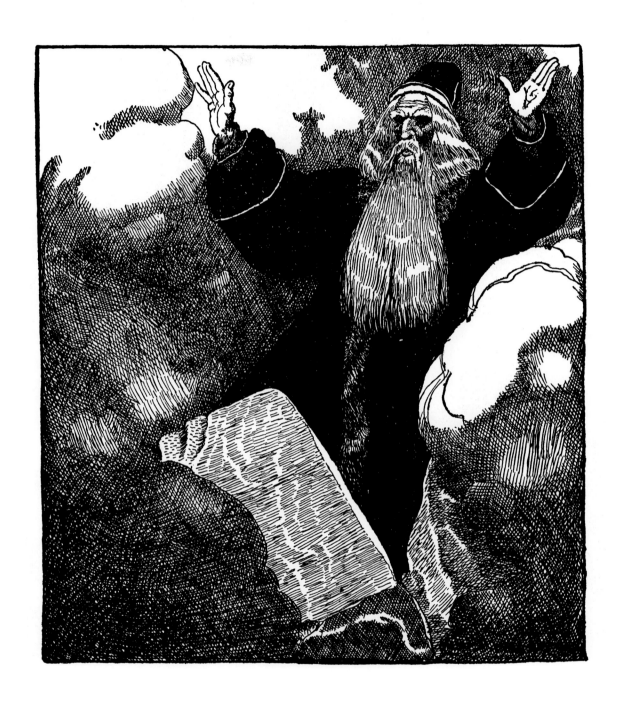

Merlin prophesieth from a cloud of mist
The Story of Sir Launcelot and his Companions

HOWARD PYLE

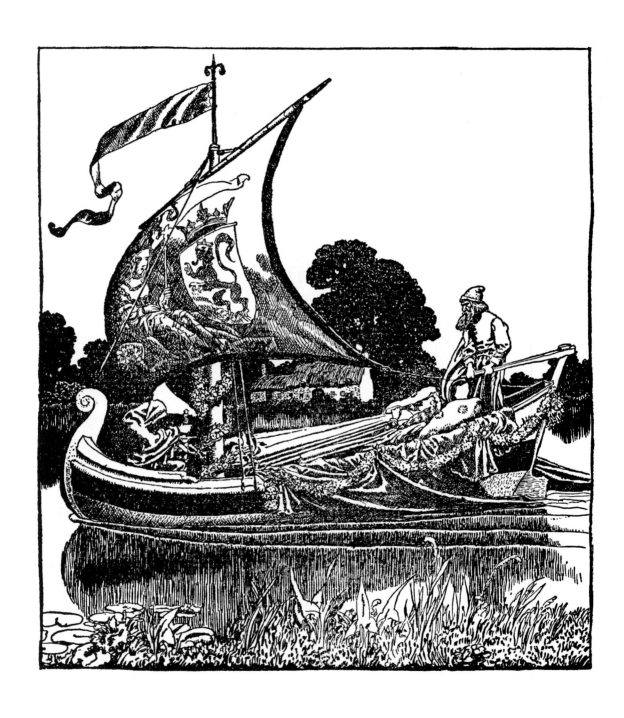

The Barge of the Dead
The Story of Sir Launcelot and his Companions

HOWARD PYLE

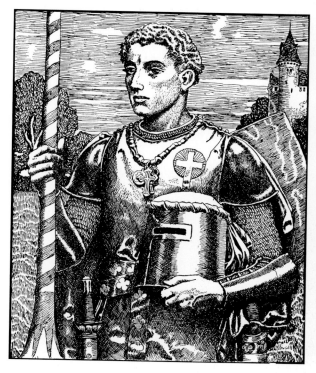
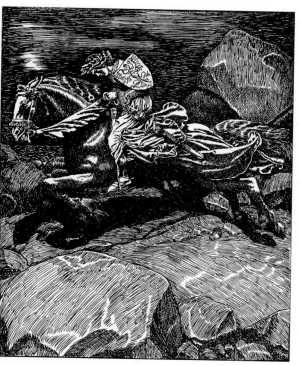
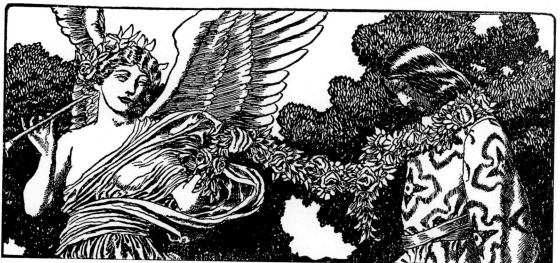

TOP LEFT: Sir Galahad of the Grail
TOP RIGHT: Sir Percival rideth the black horse
BOTTOM: Chapter Head
The Story of the Grail and the Passing of Arthur

HOWARD PYLE

How Arthur drew his sword Excalibur for the first time

ARTHUR RACKHAM

ARTHUR RACKHAM, 1867–1939
The Romance of King Arthur, 1917

As the leading figure in British children's book illustration in the early twentieth century, Arthur Rackham developed a sensitive and fluid line quality that gave his imagery a unique, organic feel—perfect for rendering a myriad of characters that one might cross in an enchanted wood. In 1905, Rackham, along with publisher William Heinemann, produced a volume that would shape children's books for years to come. This Rackham edition of Washington Irving's *Rip Van Winkle* had an unprecedented fifty-one color plates, making it a treasured gift for fortunate recipients. Great success followed, and Rackham would go on to produce hundreds of line and color illustrations for the book industry during the length of his career. Rackham's work in 1917 for Malory's *Romance of King Arthur* came during a period of great productivity for the artist. Arthur Rackham continued to illustrate books for the full length of his career.

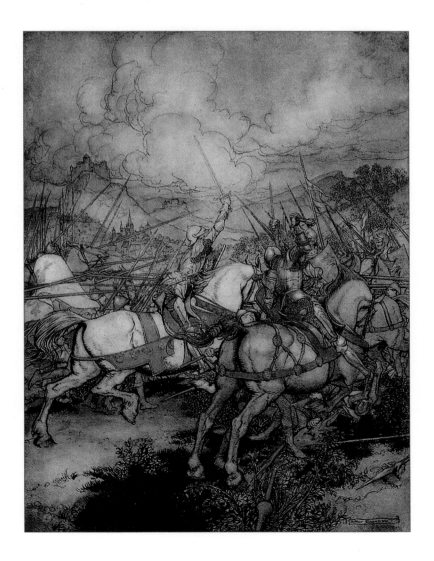

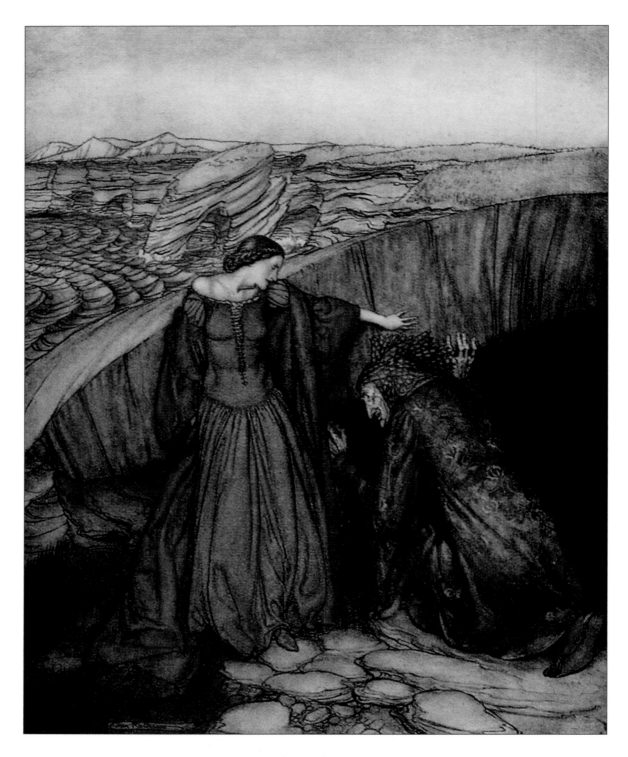

Merlin and Nimue
How by her subtle working she made Merlin to go under the stone to let her wit of the marvels
there: and she wrought so there for him that he came never out for all the craft he could do

ARTHUR RACKHAM

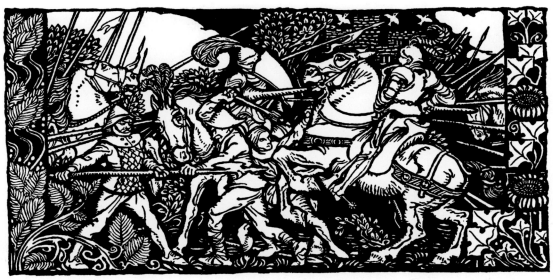

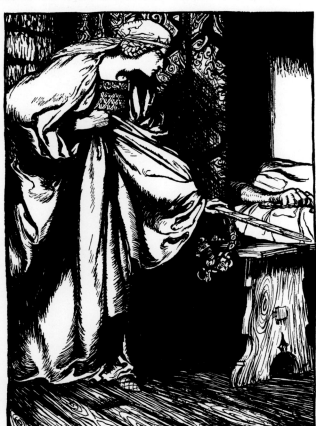

Top: Chapter decoration
Left, Top and Bottom: Two page decorations
Right: How Queen Morgan le Fay made great sorrow for the death of Accolon,
and how she stole away the scabbard from Arthur, and of the mantle she sent to him

ARTHUR RACKHAM

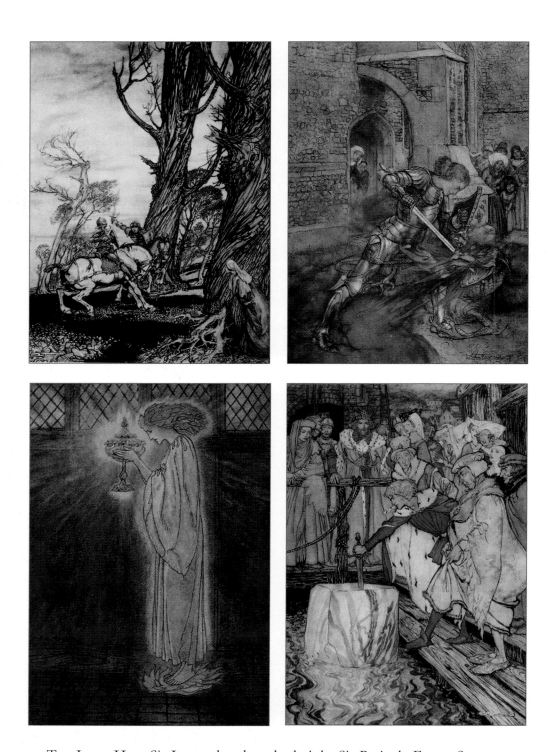

TOP LEFT: How Sir Launcelot slew the knight Sir Peris de Forest Savage
that did distress ladies, damosels, and gentlewomen
TOP RIGHT: How Sir Launcelot fought with a fiendly dragon
BOTTOM LEFT: How at the Castle of Corbin a maiden bare in the Sangreal
and foretold the achievements of Galahad
BOTTOM RIGHT: How Galahad drew out the sword from the floating stone at Camelot

ARTHUR RACKHAM

90

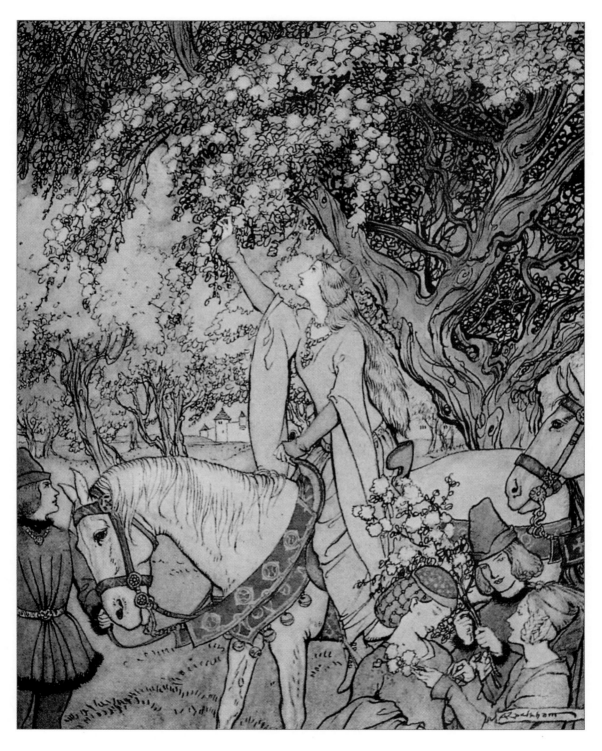

How Queen Guenever rode a-maying into the woods and fields beside Westminster

ARTHUR RACKHAM

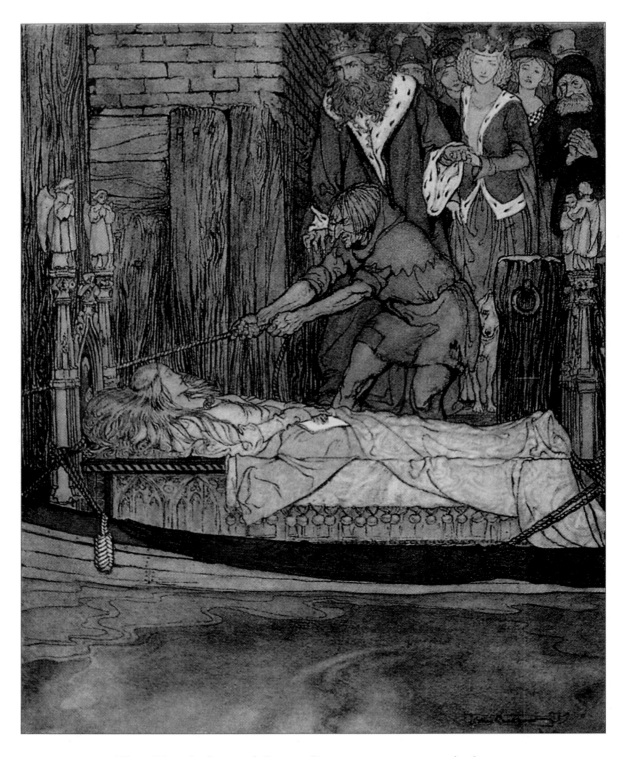

How King Arthur and Queen Guenever went to see the barge
that bore the corpse of Elaine the Fair Maiden of Astolat

ARTHUR RACKHAM

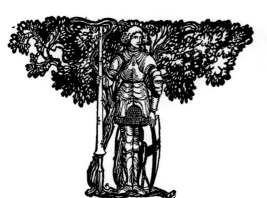

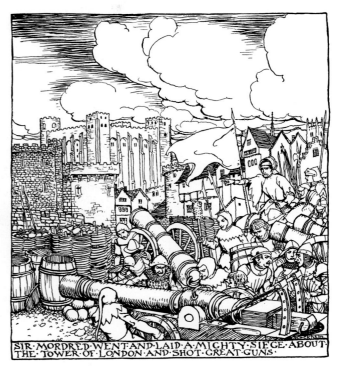

SIR·MORDRED·WENT·AND·LAID·A·MIGHTY·SIEGE·ABOUT
THE·TOWER·OF·LONDON·AND·SHOT·GREAT·GUNS.

LEFT, TOP AND BOTTOM: Two page decorations
TOP RIGHT: Sir Mordred went and laid a mighty siege
about the Tower of London and shot great guns
BOTTOM: Chapter decoration

ARTHUR RACKHAM

93

How King Arthur received the sword "Excalibur"

LOUIS RHEAD

LOUIS RHEAD, 1858–1926
King Arthur and his Knights, 1923

Though Louis Rhead did not enjoy the same popularity as Arthur Rackham or Howard Pyle, he was one of a few artists who received steady book-illustration work for most of his career. Rhead's formula for success lay in quantity—from 1909 to 1925, the artist produced no fewer than nine volumes, each offering close to one hundred pieces of line illustration. While illustrated classics with a dozen or so color plates were being produced by some publishing houses, Rhead's books had a far greater number of illustrations, nearly one image for each spread. The lack of color plates helped to minimize the cost, and the Rhead books found their way into a wide range of homes.

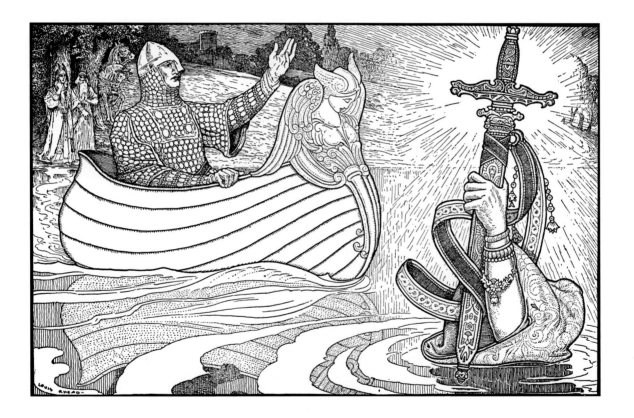

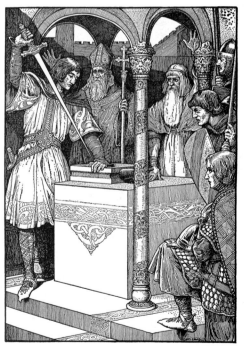

TOP: Chapter and page decorations
BOTTOM LEFT: Merlin, the Enchanter
BOTTOM RIGHT: How Arthur drew forth the sword

LOUIS RHEAD

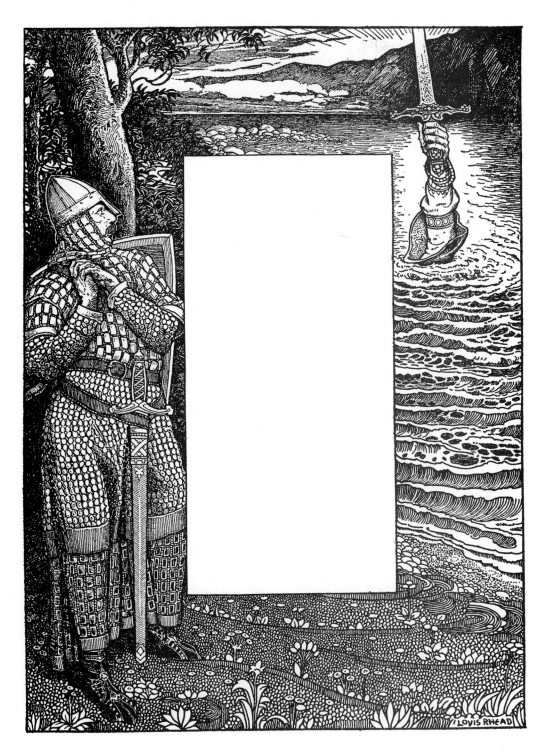

Title-page art

LOUIS RHEAD

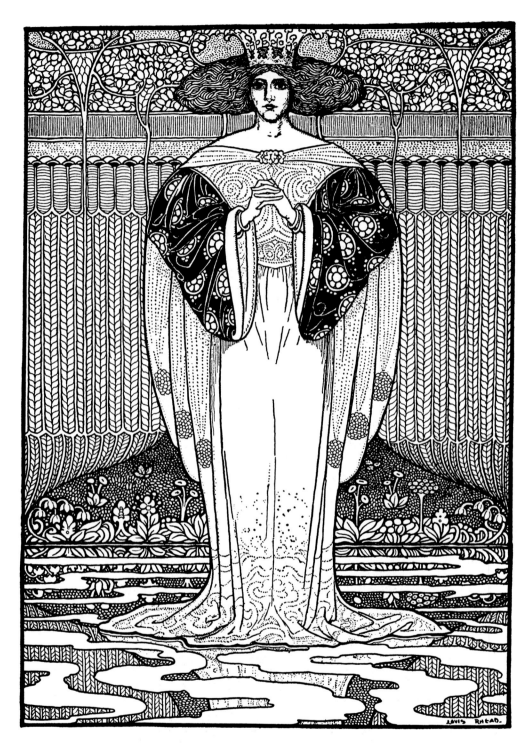

The Lady of the Lake

LOUIS RHEAD

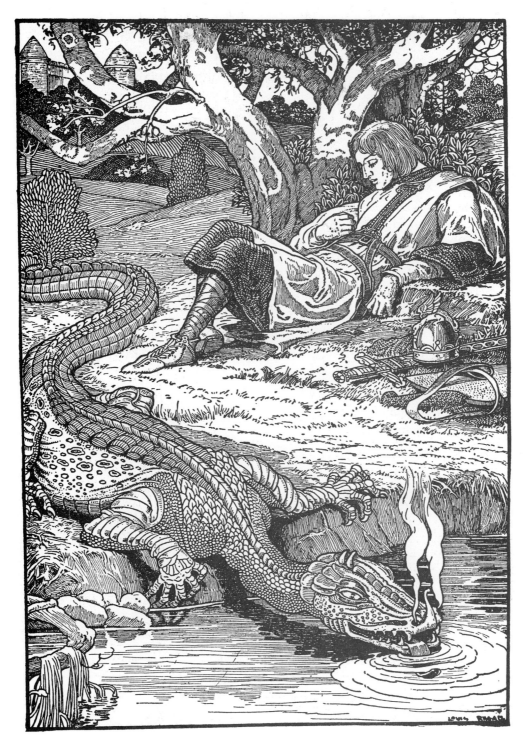

Arthur and the questing beast

LOUIS RHEAD

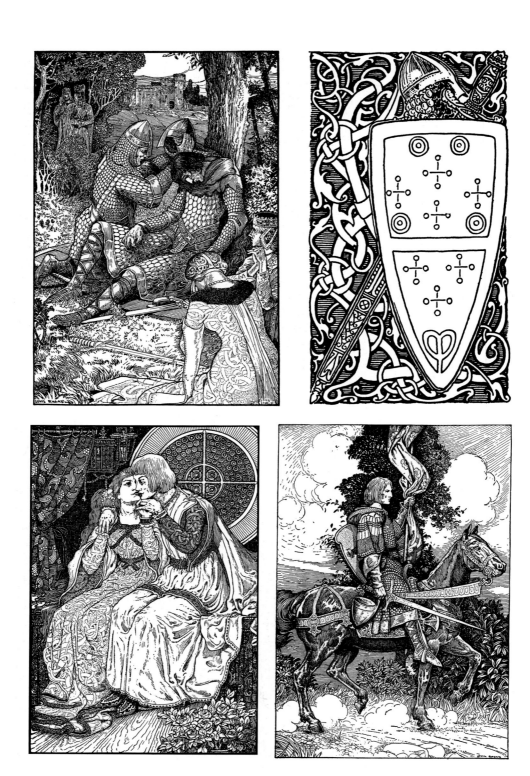

Top Left: "Oh! Balan, mine own brother, thou hast slain me, and I thee!"
Top Right: Page decoration
Bottom Left: And so they plighted their troth to each other
Bottom Right: How Sir Tristram rode away to Tintagil

LOUIS RHEAD

100

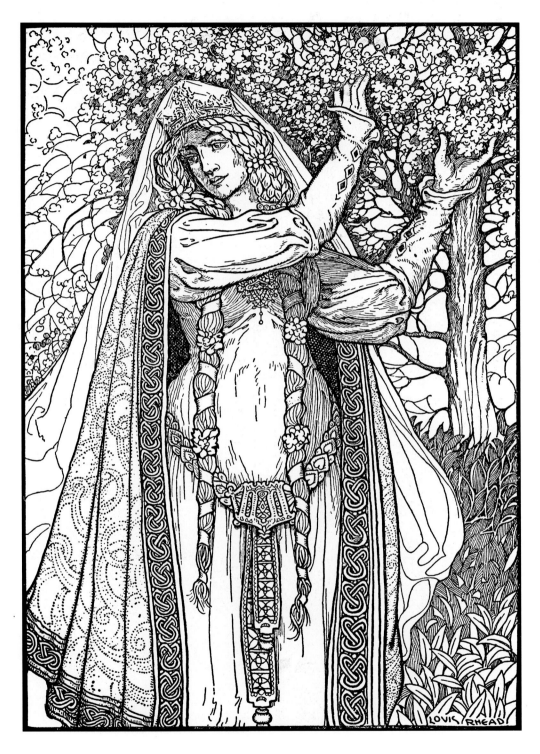

Queen Guinevere goes a-maying

Louis Rhead

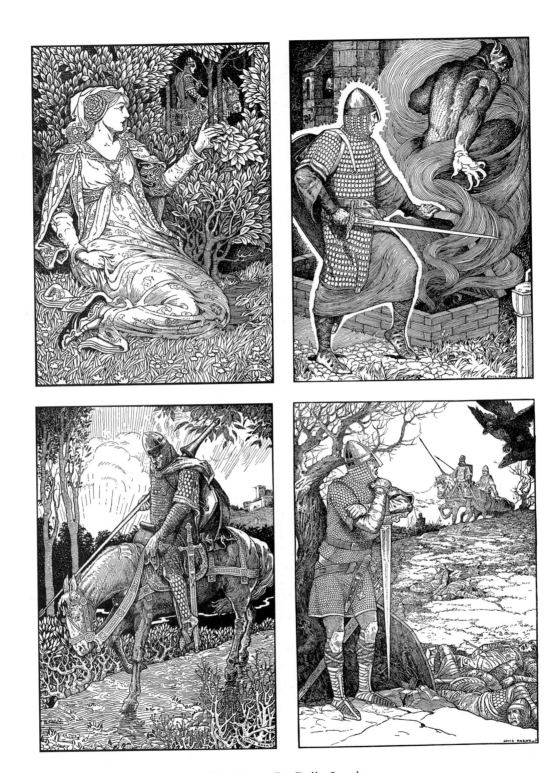

TOP LEFT: La Belle Isault
TOP RIGHT: "Oh, Galahad, I cannot tear thee as I would"
BOTTOM LEFT: Sir Modred in great fear and pain fled from the court
BOTTOM RIGHT: Betide me life, betide me death, now I see him yonder alone"

LOUIS RHEAD

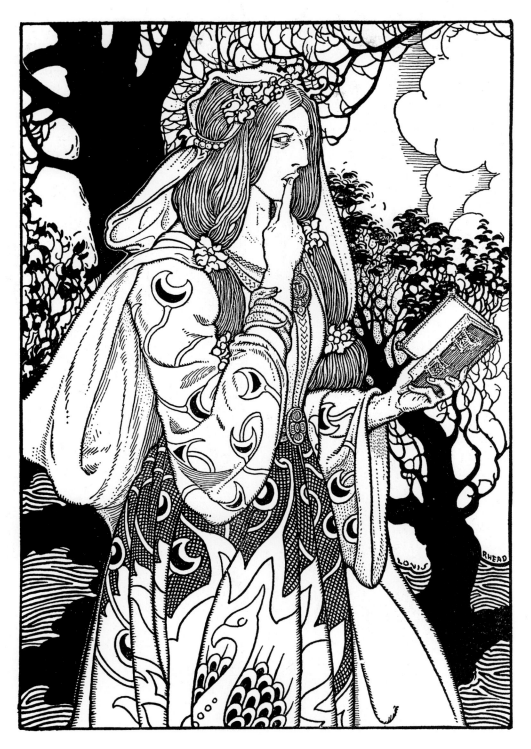

The Wily Vivien

LOUIS RHEAD

Title page

N. C. WYETH

N. C. Wyeth, 1882–1945
The Boy's King Arthur, 1917

The prize student of Howard Pyle, N. C. (Newell Convers) Wyeth would inherit his teacher's mantle as the top illustrator of youth-oriented adventure stories in America. Wyeth's pivotal moment came in 1911 with the publication of his first Scribner's Illustrated Classics for young readers. The release of *Treasure Island* was such a success that Wyeth's career was secured for decades to come. Many of Wyeth's best-loved images came from the Scribner's series; in 1917 his fourth title in the run was *The Boy's King Arthur*, adapted by Sidney Lanier. This collection has many highly dynamic pieces that combine Wyeth's artistic talents with dramatic interpretations of key moments in Arthurian legend. N. C. Wyeth left behind an extraordinary artistic legacy, with his son Andrew and his grandson Jamie Wyeth among the most highly regarded twentieth-century American painters.

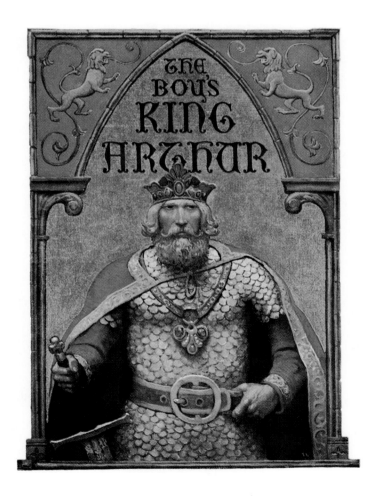

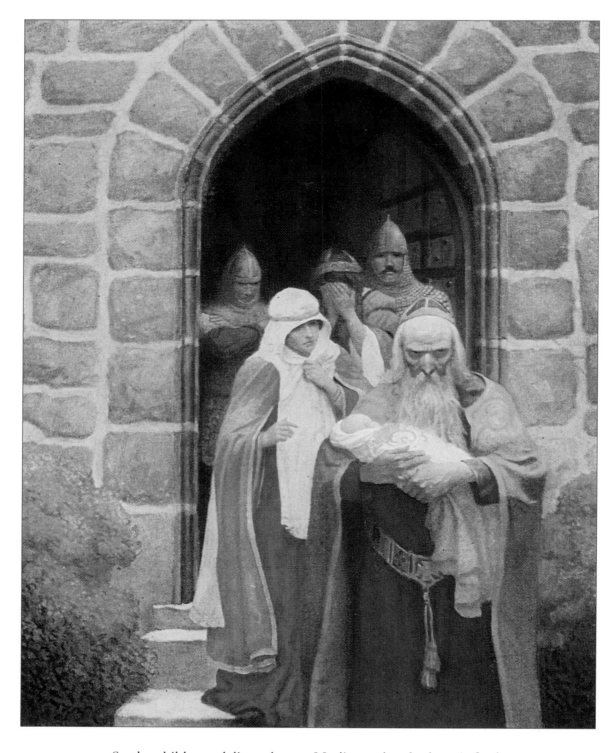

So the child was delivered unto Merlin, and so he bare it forth

N. C. WYETH

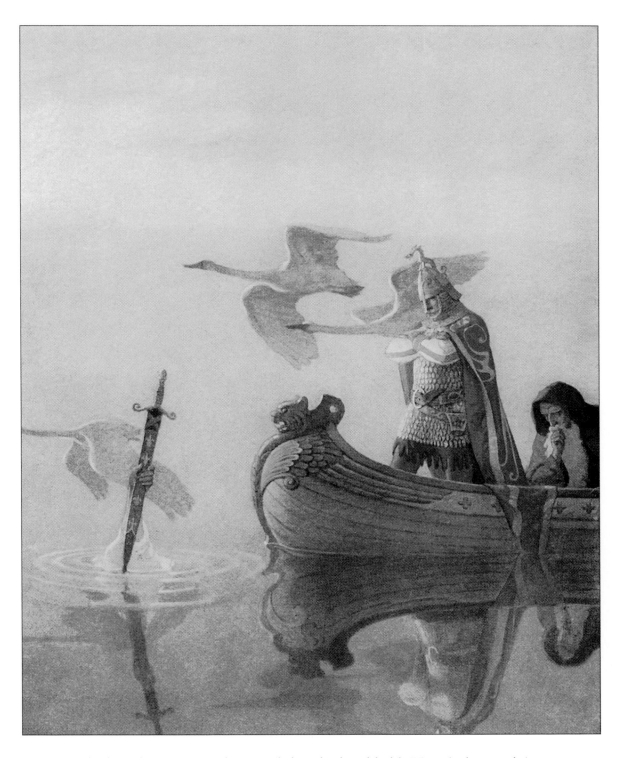

And when they came to the sword that the hand held, King Arthur took it up

N. C. Wyeth

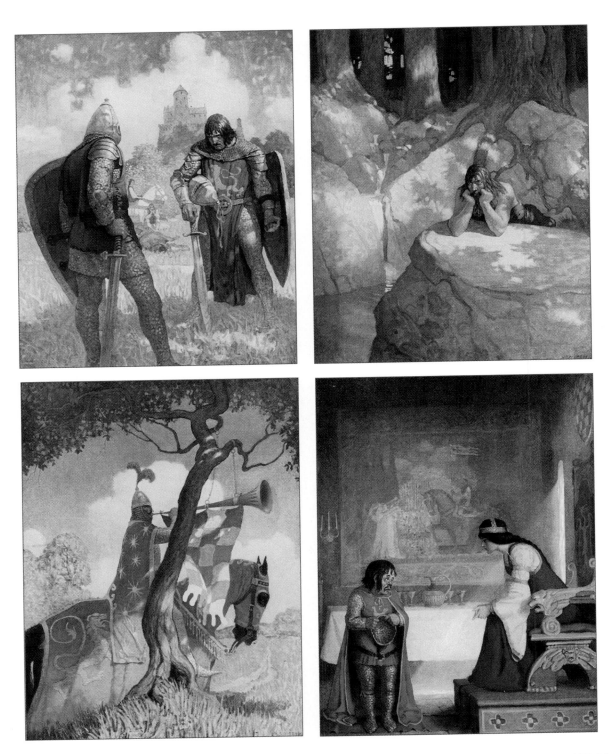

TOP LEFT: "I am Sir Launcelot du Lake, King Ban's son of Benwick, and knight of the Round Table"
TOP RIGHT: And lived by fruit and such as he might get
BOTTOM LEFT: It hung upon a thorn, and there he blew three deadly notes
BOTTOM RIGHT: The lady Lyoness . . . had the dwarf in examination

N. C. WYETH

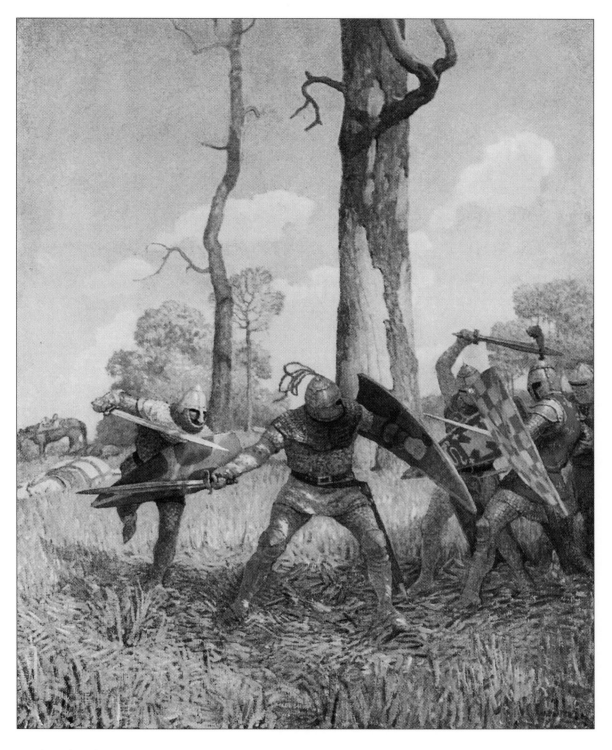

They fought with him on foot more than three hours, both before him and behind him

N. C. WYETH

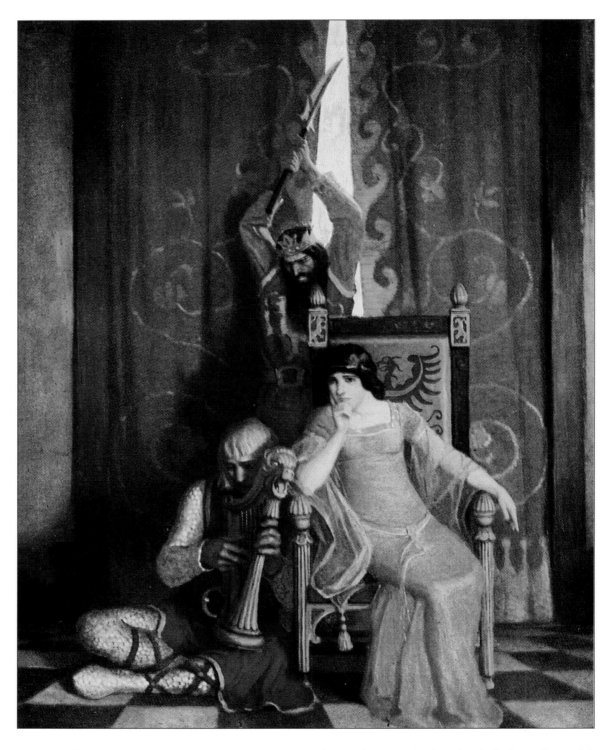

King Mark slew the noble knight Sir Tristram as he sat harping before his lady la Belle Isolde

N. C. WYETH

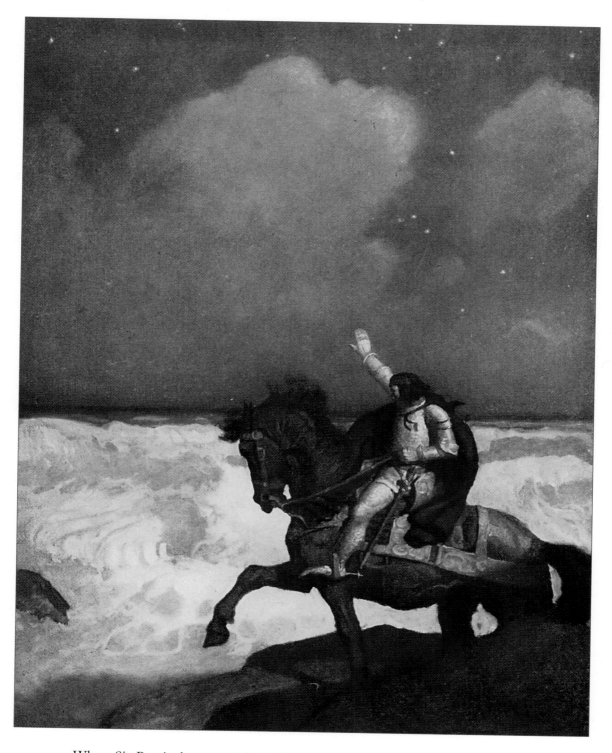

When Sir Percival came nigh the brim, and saw the water so boisterous,
he doubted to overpass it

N. C. WYETH

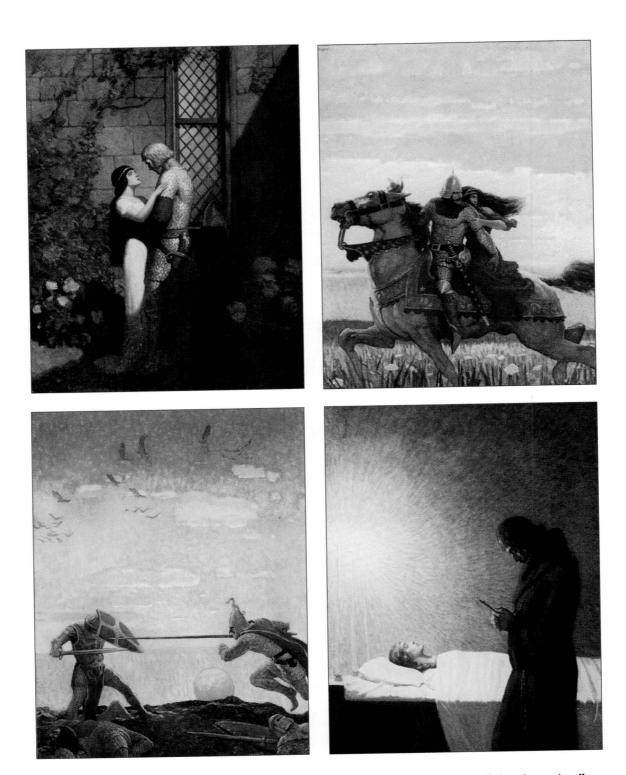

Top Left: "Oh, gentle knight," said la Belle Isolde, "full woe am I of thy departing"
Top Right: He rode his way with the queen unto Joyous Gard
Bottom Left: Then the king . . . ran towards Sir Mordred, crying,
"Traitor, now is thy death day come"
Bottom Right: Then Sir Launcelot saw her visage, but wept not greatly, but sighed

N. C. Wyeth

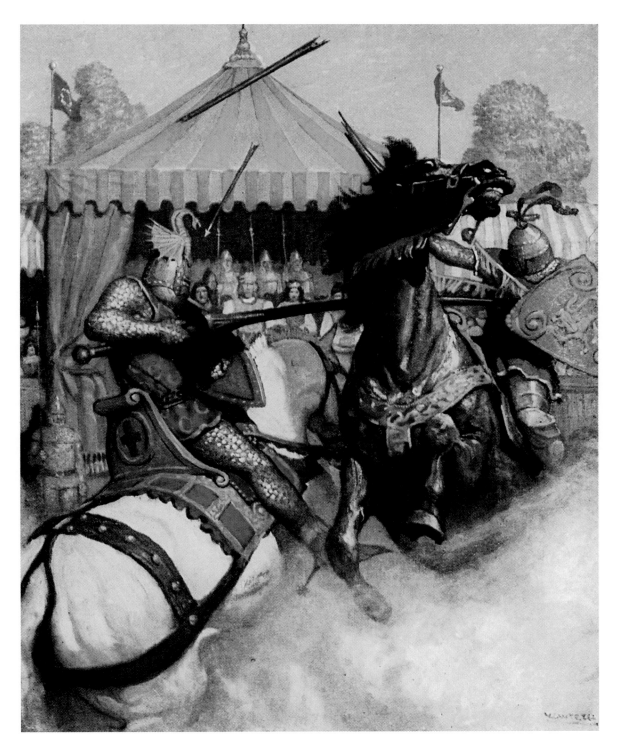

Sir Mador's spear brake all to pieces, but the other's spear held

N. C. WYETH